The Watercolorist's Essential Notebook: Landscapes

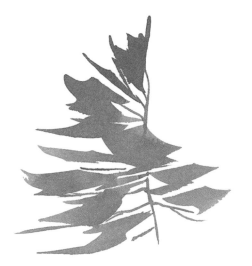

SPRING MEDLEY
11" × 14" (28cm × 36cm)

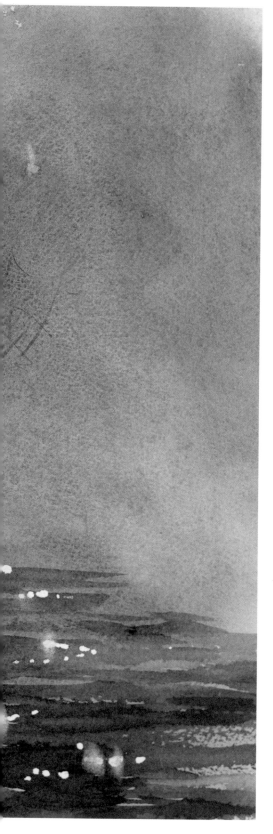

The Watercolorist's Essential Notebook

Landscapes

Gordon MacKenzie

NORTH LIGHT BOOKS
CINCINNATI, OHIO
www.artistsnetwork.com

Acknowledgments

The best way to learn something is to teach it, and the best way to teach is to learn from your students. With this in mind, I acknowledge all that I have learned over the years, both directly and indirectly, from my students. I also wish to recognize the many dear friends and colleagues whose real and spiritual support over the past five years has made this book possible. And a special thanks to Pam Wissman, acquisitions editor, who made the opportunity happen.

The Watercolorist's Essential Notebook: Landscapes. Copyright © 2006 by Gordon MacKenzie. Manufactured in China. All rights reserved. No part of this book may be reproduced in any form or by any electronic or mechanical means including

information storage and retrieval systems without permission in writing from the publisher, except by a reviewer who may quote brief passages in a review. Published by North Light Books, an imprint of F+W Publications, Inc., 4700 East Galbraith Road, Cincinnati, Ohio, 45236. (800) 289-0963. First edition.

Other fine North Light Books are available from your local bookstore, art supply store or direct from the publisher.

10 09 08 5 4 3 2

DISTRIBUTED IN CANADA BY FRASER DIRECT
100 Armstrong Avenue
Georgetown, ON, Canada L7G 5S4
Tel: (905) 877-4411

DISTRIBUTED IN THE U.K. AND EUROPE BY DAVID & CHARLES
Brunel House, Newton Abbot, Devon, TQ12 4PU, England
Tel: (+44) 1626 323200, Fax: (+44) 1626 323319
Email: mail@davidandcharles.co.uk

DISTRIBUTED IN AUSTRALIA BY CAPRICORN LINK
P.O. Box 704, S. Windsor NSW, 2756 Australia
Tel: (02) 4577-3555

Library of Congress Cataloging-in-Publication Data
MacKenzie, Gordon.
The watercolorist's essential notebook, landscapes / Gordon MacKenzie.—1st ed.
 p. cm.
 Includes index.
 ISBN-13: 978-1-58180-660-1
 ISBN-10: 1-58180-660-4
1. Landscape in art. 2. Watercolor painting—Technique. I. Title: Landscapes. II. Title.

ND2240.M155 2006
751.42'2436—dc22
 2005025171

Production edited by Stefanie Laufersweiler
Designed by Lisa Holstein
Production art by Lisa Holstein
Production coordinated by Mark Griffin

Metric Conversion Chart

To convert	to	multiply by
Inches	Centimeters	2.54
Centimeters	Inches	0.4
Feet	Centimeters	30.5
Centimeters	Feet	0.03
Yards	Meters	0.9
Meters	Yards	1.1
Sq. Inches	Sq. Centimeters	6.45
Sq. Centimeters	Sq. Inches	0.16
Sq. Feet	Sq. Meters	0.09
Sq. Meters	Sq. Feet	10.8
Sq. Yards	Sq. Meters	0.8
Sq. Meters	Sq. Yards	1.2
Pounds	Kilograms	0.45
Kilograms	Pounds	2.2
Ounces	Grams	28.3
Grams	Ounces	0.035

About the Author

Gordon MacKenzie is a native of New Liskeard in northern Ontario. He now lives in Sault Ste. Marie, Ontario, where he maintains his painting and closeness to the outdoors. Even though it precluded any formal art instruction, the remoteness of northern Ontario became the inspiration behind Gordon's work. His paintings reflect his emotional bond with the natural world.

"An artist's work is a reflection of their personal aesthetics; the ordinary things that have extraordinary and hidden beauty, meaning and significance just for them. These perceptions are set at an early age, and for me it was the spirit of remote Northern lakes and forests speaking in breathtaking images for the eye and timeless silence for the soul."

Gordon received his first formal art training at the Ontario College of Art and Design while certifying as a visual arts specialist in education. Work in a variety of media followed, but none captured the transient and ethereal nature of the land as he saw it until the early 1970s when he switched to watercolors. He has been a devoted watercolorist ever since.

Gordon has now retired after thirty-three years as a teacher and art consultant for the Sault Ste. Marie Board of Education. As a graduate of Laurentian University and a specialist in art education, he has taught ministry of education and university-level art education courses for teachers for many years. With over twenty-five years of teaching private adult watercolor workshops as well, Gordon has earned a reputation as a first-class artist and instructor. Gordon has had twenty-six solo watercolor shows in Canada and the U.S., and his work appears in many private and corporate collections throughout Canada, the U.S., Europe, Africa and the Far East. He has received honors in several American shows, including that of the Detroit Institute of Art and the American Artist annual competition. He is a member of the Canadian Society of Painters in Watercolour and author of the very successful *The Watercolorist's Essential Notebook* (North Light Books, 1999).

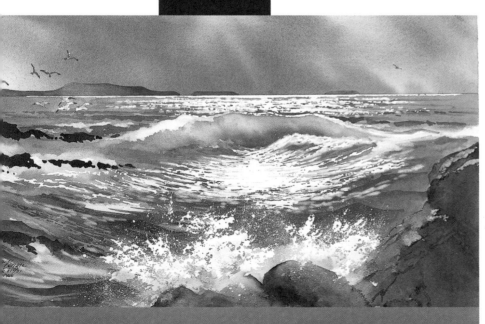

Dedication

For Jane,
who taught us all how to live this life, and now guides our hearts from afar.

DEPARTURE
11" × 19" (28cm × 48cm)

Table of Contents

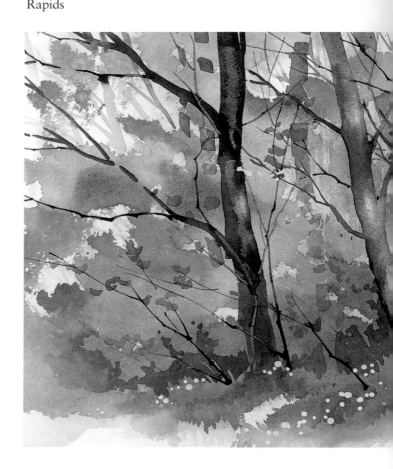

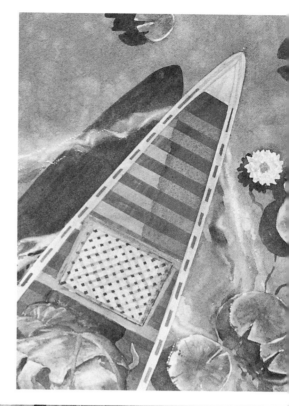

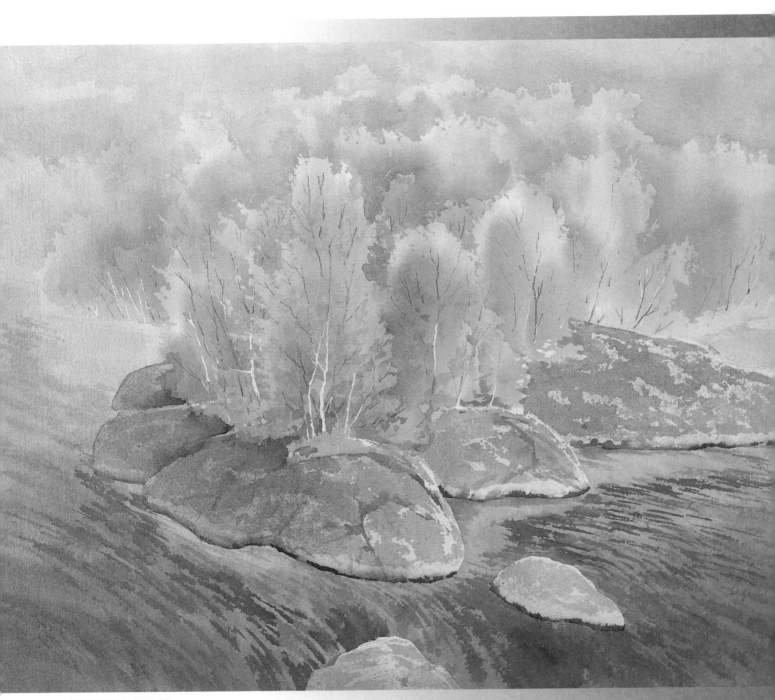

OCTOBER POINT
15" × 22" (38cm × 56cm)

Landscape painting is our interpretation of how the land has energized us. Deep within our being it touches chords, which are then played out as images on our paper.

—Gordon MacKenzie

Introduction

I am sorry if you bought this book thinking that you would become a full-blown artistic wonder overnight just by reading it. The arts are about doing, making and creating something, and that takes time. It also takes practice—lots of it. To assume that every piece of paper you use should end as a masterpiece is like assuming that every time a violinist picks up the instrument he or she must perform a flawless concerto.

They say that you will learn something from every painting regardless of how it turns out. Believe me, there have been many, many times when I have learned a lot more than I really wanted to from a painting.

And the lessons are often on just one small aspect of the total picture. This book tries to address this way of learning. It reflects what I have noticed about students' needs in workshops. They want to see the finished picture but they also want specifically to learn about painting such things as rocks or reflections or storm clouds. They ask about color qualities and compositional processes. They want to know about techniques that will help them make better pictures, and they want to know what is going on in my head when I create. (That one is a bit of a mystery in itself.)

All these things help them focus on their particular needs, but what I also want them to do in workshops and with this book is stand back and see the whole picture-making process for what it is. For in the end, it is not about how well you can paint but how much you have grown. In the final measure, it is not the number of accolades you gain but how well you share and celebrate the gift of the creative spirit.

There are three sections in this book. Chapter one deals with the essential techniques and information that you need to work with watercolors. Chapter two is about taking control of your composition. Chapter three comprises the biggest part of this book and covers the specifics of painting water, sky and land. Each is dealt with separately so that you can focus and experience numerous ways of portraying just that element. As often as possible, I have tried to show more than one way of doing something. That will leave you with a lot of partial pictures, but these can be added to and completed later if you wish.

Please remember that what value you get from this book does not depend on which exercises you do today but the variations of your own that you paint tomorrow. In that sense, this book is only a stepping stone, a doorway, a reference point. It is up to you to move forward.

And so, I wish you good luck and good fortune on your creative journey. May the path lead you to places of profound joy and personal fulfillment.

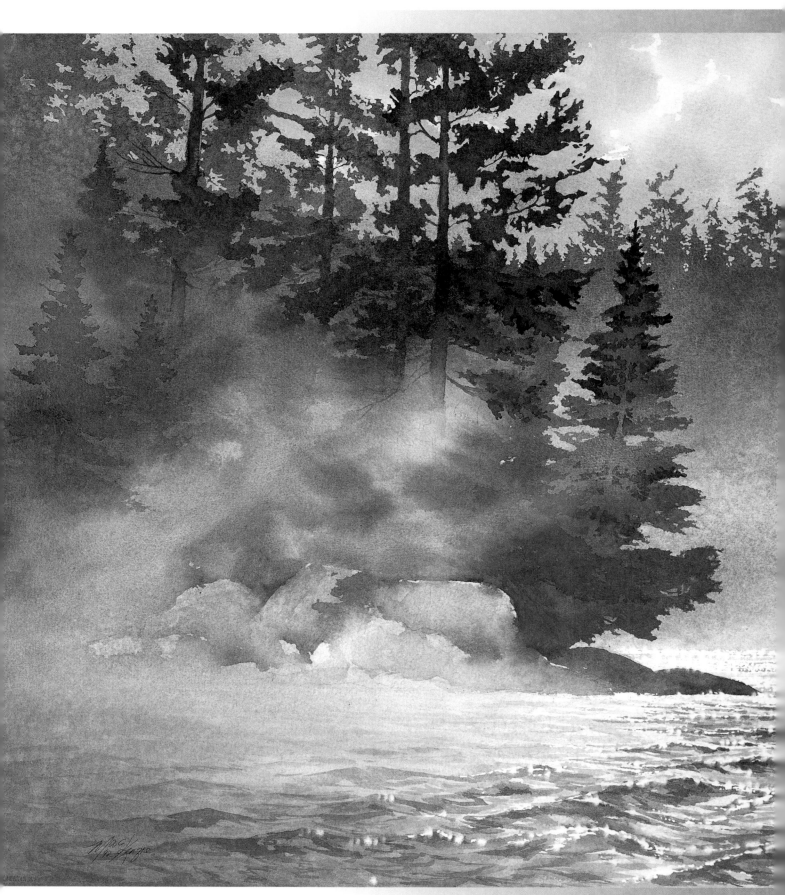

ENTRANCE
22" × 30" (56cm × 76cm)

The Medium, Tools and Techniques

1

Watercolor: a process of applying colored water to a piece of paper so that you can watch, spellbound, while it evaporates; a quest to experience all the subtleties and nuances of diluting paint.

Right.

You're probably thinking that you should have taken up something a little more dynamic, like knitting, but please read on. For all the simplicity at its core, watercolor is still a most powerful medium that is more than capable of capturing every mood and vision you can imagine.

This chapter is a summary of the medium, tools and essential techniques and procedures that you will need for painting in watercolors in general and for working through the specific exercises and demos found later on.

Before We Start

THE MEDIUM

On countless occasions I've had non-watercolorists make the comment, "I understand that watercolors are the hardest medium to work with," to which I reply in all seriousness, "Why of course, by all means, they are indeed extremely difficult to handle. It takes an extraordinary amount of talent, unbelievable patience and a really winning personality to handle this medium." If they don't catch the tongue-in-cheek of my reply, then I let them live on with their delusions. Ironically, the most important part of my reply is the part about personality, because so much of what is personality is attitude, and in watercolors, attitude is everything.

Even the medium has an attitude. Try to beat it up, push it around, force it to perform to your will, and it will turn on you. It will take the joy right out of your days and rob the hours of your nights. Only when you assume the role of student to the medium and partner in the creative process will you set the stage for endless growth and discovery in watercolor.

THE TOOLS

Just about anything that will apply, move or lift paint has been tried in watercolor. Traditionally, brushes of all shapes and sizes have been the tool of choice for watercolorists, but if one is not too mired mentally in tradition, there are other ways of delivering and manipulating paint and water—such as palette knives, toothbrushes, sponges, cloth, found objects, syringes, even sticks. In fact, after hands and fingers, sticks were

Ms. Swampgas decides to modify her paint stick.

the tool of choice for many years until some distant ancestor decided to add hair to theirs. Can you imagine the uproar of traditionalists vowing never to try those newfangled gimmicks called 'brushes'? Things haven't change much, but in watercolor you are free to push the boundaries on those days when you feel a brush is just not enough. By the way, buy the best sticks you can.

THE TECHNIQUES

"Techniques" or "procedures" simply means the alternative ways of applying, manipulating and removing paint. You might see some referred to as "tricks" from time to time, as if they were the unpredictable results of happenstance, sort of secret shortcuts for lazy painters in a hurry. Understand that they are anything *but* this. They are indeed the result of very creative and very knowledgeable minds determined to let the characteristics of the medium work their magic. These artists are determined to let the paint share in the creation of the work. They know that the techniques are there only to support the visual statement, but they also know that the proper technique, just as the proper brush, can free them from needless brushwork so that they can focus on their creative flight.

Pigment Characteristics

Knowing a paint's characteristics puts you at a distinct advantage. For example, transparent colors maintain their luminosity because they allow light to pass through and reflect back from the paper. On the other hand, opaque colors block the light. The more opaque a color, the more it blocks light, especially if it is built up in layers.

If you want to glaze one color on top of another so that you can see the colors mixing, use transparent colors of any strength or thinned opaques. If you want to produce a really dark color that has depth, use full-strength transparent colors. To capitalize on the beauty of opaque colors, avoid multiple layers if applied full strength; otherwise, thin them out (e.g., work on wet or damp paper) to reveal their hidden beauty.

Adding an opaque color to a mixture will invariably turn it to mud.

If you plan to lift paint back to white paper as part of your technique, avoid the staining colors. If you wish to lift one color of a mixture to reveal a second color below it (by scraping with a knife, blotting, etc.), then use a stainer and non-stainer mixture. If you wish to lift color and leave an after-image of the same color, use all stainers.

PIGMENT NUMBERS

The pigments used throughout the world for all sorts of color work are given letter/number codes. The letters indicate the pigment's hue. For example, PB means "pigment blue." The numbers are those assigned internationally for that pigment material. The codes are the easy way to remember complex pigment names.

The quality of pigments varies considerably, and although not all pigments need to be permanent (for example, when printing colored flyers for the newspaper), we do want the best durability possible for our paintings. An unreliable color will usually fade with time or moisture, but some darken or shift color. An unreliable color is unreliable no matter what extenders, binders or other pigments it is mixed with.

Interestingly enough, paints made with quality pigments cost no more than those without. As more artist have become aware of pigment reliability, the quality of paints on the market have improved.

Transparent Staining		Transparent Low- or No-Staining		Semi-Transparent Low-Staining		Semi-Opaque to Opaque Low-Staining	
Phthalo Green	PG7	Viridian	PG18	Lemon Yellow	PY3	Permanent Red	PR101, PR102*
Phthalo Blue	PB15	Cobalt Blue	PB28	Quinacridone Gold	PO48, PO49		
Prussian Blue	PB27	Ultramarine Blue	PB29			Cadmium Red Light	
Thioindigo Violet	PR88 MRS	Quinacridone Red Quinacridone Violet (Rose and Ruby paints)	PR209	Gamboge (original, new or hue)	*	Cadmium Red Medium	PR108
Indian Yellow	*		PR192			Cadmium Red Deep	
Aureolin	PY40		PV19	Raw Sienna	PBr7	Cadmium Scarlet	*
			PR206	Burnt Sienna	PBr7	Cadmium Orange	PO20
			PR207	Raw Umber	PBr7	Cadmium Yellow Light	
				Sap Green	*	Cadmium Yellow Medium	PY35, PY37
				Hooker's Green	*	Cadmium Yellow Deep	
				Ultramarine Violet	PV15 (better to mix PB29 + PV19	Yellow Ochre	PY42, PY43
						Venetian Red English Red Indian Red	PR101
						Burnt Umber	PBr7
						Phthalo Yellow Green	*
						Permanent Yellow Green	*
						Cerulean Blue	PB35 or PB36
						Indigo	*
						Payne's Gray	*
						Chrome Oxide Green	*
						Sepia	PG17
						Naples Yellow	*

** These colors are mixtures and vary with the manufacturer.*

PIGMENT CHARACTERISTICS CHART

The reliable colors in this chart are grouped according to their staining abilities and opacity. Pigment numbers are shown to the right of each color for your reference.

Once you start looking at pigment numbers on your paint tubes, you will realize that there is a lot of duplication out there.

WHAT'S IN A NAME?

Over the past several years numerous paint manufacturers have reintroduced colors that were once very popular but had fallen into disrepute because of the unreliable pigments they contained. They knew the marketing value of an established and popular name and so reformulated their colors to keep those names while satisfying an increasingly more informed market. However, there are still many of tubes of unreliable paint being put out there under the same popular names, so we really must read those labels. The "Common Culprits" chart shows some of these reintroduced names. Double-check to make sure they contain none of the pigments I recommend you avoid.

A-SHOPPING WE WILL GO

You really don't need the numbers of the reliable pigments when you go shopping. All you need are the ones to avoid. Unfortunately they don't often list pigment numbers in catalogs or on websites, so it becomes hard to know what you are buying from these sources. If that's the case, check out the chart on the next page. It lists the more reliable colors from many of the major suppliers. By the way, the pigments below represent only about 25 percent of the pigments available for paintmaking, which means that there are a lot of good ones out there.

Carefully Check These Common Culprits

	Color	Names
	Yellow	Indian Yellow, Gamboge (new, original or hue)
	Red	Crimson Lake, Scarlet, Vermillion, Permanent Red
	Violet	Mauve, Violet
	Green	Phthalo Yellow Green, Permanent Yellow Green, Hooker's Green, Sap Green

Pigments to Avoid

	Color	Pigments
	Yellow	PY1, PY1:1, PY12, PY13, PY17, PY20, PY24, PY34, NY24, PY55, PY100
	Orange	PO1, PO13, PO34, PO65
	Red	Every red pigment number below 100 except PR88MRS.
		Plus: NR4, NR9, PR104, PR105, PR106, PR112, PR122, PR146, PR173, PR210
	Violet	PV1, PV2, PV3, PV4, PV5AL, PV23, PV23BS, PV23RS, PV37, PV39
	Blue	PB1, PB4, PB66
	Green	PG1, PG2, PG8, PG12
	Brown	NBr8, PBr8, PBr24

Pigments By Any Other Name...

If you have any of these colors, you won't need to buy Phthalo Blue (PB15):	
Talens	Rembrandt Blue
Lukas	Helio Blue
LeFranc Bourgeois	Hoggar Blue and Hortensia Blue
Maimeri	Berlin Blue
Pebeo	Cyanin Blue
Holbein	Antique Bronze Blue
Daler-Rowney	Monestial Blue
Winsor & Newton	Winsor Blue and Intense Blue
Schminke	Brilliant Blue
American Journey	Joe's Blue

If you have one of these colors, you also have a tube of Quinacridone Violet/Red (PV19):	
Schminke	Permanent Carmine, Rose Madder, Ruby Red
Da Vinci	Permanent Rose, Carmine, Alizarin Crimson, Red Rose Deep
Grumbacher	Carmine Hue, Thalo Red, Thalo Crimson
LeFranc Bourgeois	Crimson Lake, Ruby Red, Carmine Permanent
Lukas	Primary Red
Winsor & Newton	Permanent Rose
American Journey	Alizarin Crimson

Paint Quality Chart

This chart summarizes paint quality according to ASTM (American Society for Testing and Materials) standards for a wide range of commonly used colors from various manufacturers.

■ excellent ■ questionable

■ very good ■ not recommended

■ good □ not available

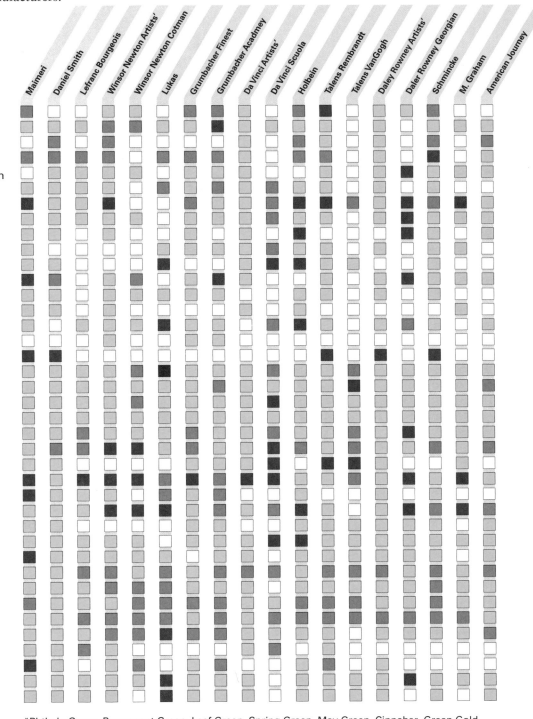

	Maimeri	Daniel Smith	Lefranc Bourgeois	Winsor Newton Artists'	Winsor Newton Cotman	Lukas	Grumbacher Finest	Grumbacher Academy	Da Vinci Artists'	Da Vinci Scuola	Holbein	Talens Rembrandt	Talens VanGogh	Daley Rowney Artists'	Daler Rowney Georgian	Schmincke	M. Graham	American Journey
Lemon Yellow																		
Cadmium Yellow Light																		
Aureolin																		
Indian Yellow																		
Cadmium Yellow Medium																		
Cadmium Yellow Deep																		
Gamboge																		
Cadmium Orange																		
Scarlet combinations																		
Cadmium Red Light																		
Permanent Red																		
Cadmium Red																		
Cadmium Red Deep																		
Quinacridone Red																		
Quinacridone Violet																		
Thioindigo Violet																		
Ultramarine Violet																		
Ultramarine Blue																		
Cobalt Blue																		
Phthalocyanine Blue																		
Prussian Blue																		
Cerulean Blue																		
Viridian																		
Phthalocyanine Green																		
Hooker's Green																		
Chrome Oxide Green																		
Sap Green																		
Yellow-greens *																		
Payne's Gray																		
Indigo																		
Burnt Sienna																		
Burnt Umber																		
Yellow Ochre																		
Raw Sienna																		
Raw Umber																		
Venetian Red																		
Indian Red																		
Sepia																		
Naples Yellow																		

*Phthalo Green, Permanent Green, Leaf Green, Spring Green, May Green, Cinnabar, Green Gold

Brush Types

Your brush is your connection between you and your painting. I strongly recommend that you buy some basic, good-quality brushes and keep them just for watercolors.

BRUSH FIBERS

Brushes are constructed with natural or synthetic fibers or a blend of these two types.

Natural fibers cover quite a range, from the kolinsky red sable, the best performing and most expensive watercolor brush of all, to the inexpensive, coarse hog-hair bristle at the other end of the spectrum. Natural fibers vary greatly in their flexibility, but all are excellent at holding moisture and releasing it slowly. Because natural fibers can lose their rigidity when wet, some can be awkward to work with.

Synthetic fibers that make an excellent, inexpensive brush have more spring or "snap" to them but hold less moisture and release it more quickly than natural fibers. For the best of both worlds, try those made with a blend of natural and synthetic fibers.

BRUSH SIZES

Misconception: A big brush is just for making big marks. Wrong. A big brush can produce some surprisingly tiny marks if you use just the corner or tip. The real difference between sizes is that the big one holds more paint. Therefore, when choosing brushes, buy a couple of big ones right from the start. The majority of experienced artists paint mostly with their biggest brushes—in order to quickly lay down juicy pools of paint without constantly reloading—and save their small brushes for detail at the end.

Top view

Side view

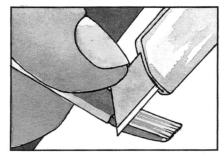

HOG-HAIR BRISTLE BRUSHES

A hog-hair bristle brush allows you to make marks that have natural looking edges. This is important when depicting natural things that have irregular edges, such as rocks, clouds, foam, foliage, fields, etc.

If you plan to try the demos in this book, you may as well go out right now and buy yourself a couple of hog-hair brushes. You will find them in art stores, catalogs and websites in the gesso/oil paint/acrylic/mural/brush sections. You will not find them in the watercolor section because they are not considered a watercolor brush. They are also known as "China" bristle. They range in size from a tiny no. 2 flat acrylic brush to a 3-inch (75mm) flat wash brush. You can sometimes find them in hardware stores masquerading as housepainting brushes. They are generally inexpensive.

THE SCRUB BRUSH YOU MAKE

This type of brush is one of the most valuable for cleaning up edges and adding highlights to your painting. You will need a sharp razor knife and a no. 2 or no. 4 flat hog-hair bristle brush. Let it soak in water for about five minutes to soften the bristles. Hold the brush on the edge of a table. Place the blade straight across the bristles but tilted back. Cut the bristles off by pushing the blade forward hard with the thumb of the hand that is holding the brush. The chisel edge is so that you can scrub off a fine line with the leading edge, or turn it over and scrub out a much larger area. Always scrub with lots of water.

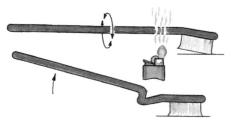

OLD TOOTHBRUSH

These are great for gently lifting paint in an open area or through a stencil. It also comes in handy for spattering paint. You can make it more functional if you bend the handle upward. Gently heat the handle and bend to the desired angle. Cool under running water.

Flat wash brush. Synthetic. Produces large, precise marks that can vary greatly in width. Medium carrying capacity.

Aquarelle brush. Synthetic. Precise smaller marks. Low carrying capacity.

Stroke brush. Synthetic. Longer bristles add greater flexibility for very precise marks. Medium carrying capacity.

Round brushes. Synthetic, natural or blended. The traditional watercolor brush. Choose ones with snap and long bristles; nos. 8, 10, 12 and 14 are most useful.

Rigger brush. Synthetic or natural fibers. Square tipped. Produces thin strokes of constant width.

Script brush. Natural or synthetic fibers. Pointed tip. Produces thin strokes of varying widths.

Mop brush. Soft, natural bristles. Used for soupy washes. No snap.

Bristle, hog bristle or hog-hair brushes. A tough, stiff workhorse of a brush that produces unique textures and edges. Maximum carrying capacity.

Wash

Long bristle wash

Student brushes

Filbert

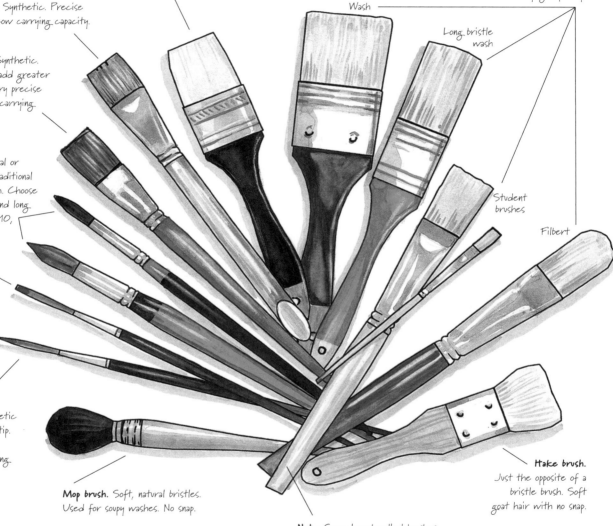

Hake brush. Just the opposite of a bristle brush. Soft goat hair with no snap.

Note: Some long-handled brushes may have to be shortened to watercolor length for better balance and maneuverability.

BRUSHES COMMONLY USED IN WATERCOLOR
Here are some of the brushes you will use in watercolor. They will allow you to perform a wide range of painting functions. A sure-fire way to spot inferior brushes is to note the quality and care put into the ferrule and handle. If it looks shoddy, keep looking.

Brush Techniques

Learning to use brushes to their fullest extent is one of the best ways to unlock the potential of this medium. It's amazing how people will pay good money for a new type of brush and then use it like all their other brushes—like a windshield wiper.

GETTING A GRIP

The worst habit that painters can get into is holding their brushes in only one way, such as like a pencil. They are missing out on what the brushes can really do, sort of like owning a sports car and only using it in the driveway. It takes a conscious effort to change your angle of attack (or grip) to vertical or underhand, but the payoff is being able to paint more freely and make marks that are more "painterly."

WORKING VERTICALLY

By holding a brush vertically, you can easily make marks that vary in width and direction. These marks constitute "real" painting, where as little as a single stroke can create a leaf, flower petal or tree trunk. This is just the opposite of the cautious coloring-book approach, where a shape is first outlined and then filled with color—usually with an under-sized brush. Break yourself of that habit as soon as you can by mastering strokes made in the vertical.

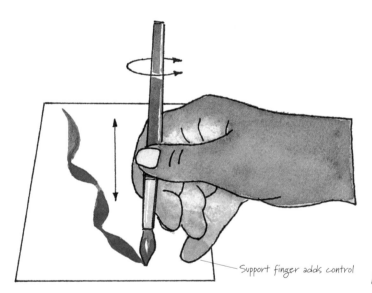

Support finger adds control

VERTICAL ROUND BRUSH

Holding your brush vertically allows you to take full advantage of the tip of a round brush. By dropping a finger you can control the pressure on the tip, and therefore the width of the line it produces. By twisting the brush through the stroke, the mark will end with a very sharp point.

Don't lift your brush until you have finished the stroke. Many of us have the bad habit of lifting our brush as we approach the end of a stroke, which produces a very weak, ragged finish. Practice making long strokes that vary in width and direction, such as blades of grass.

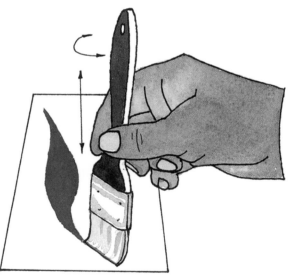

VERTICAL FLAT BRUSH

By holding a flat brush vertically and twisting ninety degrees through the stroke, you are able to make marks that vary greatly in width. If you also increase the pressure as you make the stroke, the width will be even greater. This technique is extremely useful for painting leaves, waves and flower petals.

WORKING UNDERHAND

Many artists find it far easier to create shapes when holding the brush underhand, particularly if they are standing up. Experiment with different angles and pressure applied. *Caution:* Avoid pushing your brush. The texture of the paper can grab and snap the fine tips off your synthetic brushes.

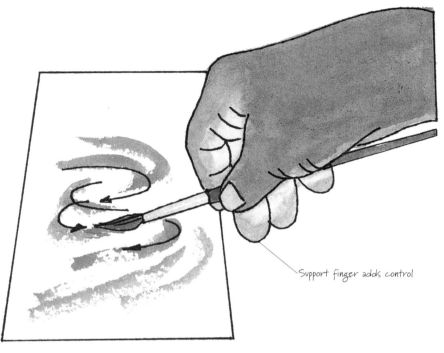

Support finger adds control

UNDERHAND ROUND BRUSH
Holding a round brush underhand allows you to make irregular drybrush-type marks with the side of the bristles. This technique can be used to texture rocks, bark, foam, clouds, etc. If the brush is dragged sideways in a line, it produces an irregular-edged shape that serves well for a rough-barked tree trunk.

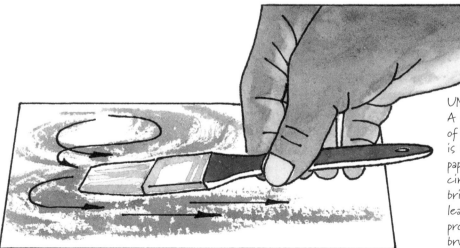

UNDERHAND FLAT BRUSH
A flat brush can produce large areas of drybrush-style marks if the brush is well loaded, held very low to the paper, and moved gently in an irregular circular pattern. Only the side of the bristles should touch the paper. If the leading edge touches, you will only produce a solid mark. If you drag the brush in one direction, you can produce a streaked lacy pattern. You may need to repeat the stroke several times in order to develop the pattern you want. Remember, keep the brush low. A hog-hair bristle brush is excellent for this.

Water

SO, WHEN DO I WET MY PAPER?

If you want your colors to blend together or your strokes to have soft edges, then wet the surface before you add paint. This is called *wet-in-wet* or *wet-on-damp* painting.

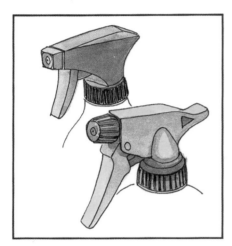

CHOOSING THE RIGHT SPRAY BOTTLE

This may seem trivial, but it's the difference between a technique requiring water spray working or not working. In most cases you'll want a sprayer that lays down a coarse pattern of drops so that when the paint meets the water, it will follow irregular lacy paths. If you use a small atomizer-type sprayer, all you are putting on the paper is a fine mist that is not wet enough to move paint. If you move in closer to apply more, all you get is a small, solid wet spot.

The two types of sprayers pictured here are found in most drug or variety stores and are quite effective because of their versatility. If you squeeze the trigger slowly on these, you get a coarse spray. If you squeeze it hard, you produce a large, fine spray that will wash paint right off the paper. Experiment with the distance from the nozzle to the paper when spraying.

When you want controlled, clearly defined brushstrokes, then paint on a dry surface (*wet-on-dry*). Of course, as soon as you put down paint you are creating a wet area into which you can now paint wet-in-wet.

The danger with painting large, complicated areas wet-on-dry is that some parts of your paint may dry to the damp stage or more before you have completely finished them. This can cause all sorts of problems, from backruns or "blossoms" to hard edges when you do add more paint. If you cannot work a bead of paint from one area to the next to avoid this, then it might be wise to pre-wet the areas to be painted. It is not necessary to wet all the way to the edges of the shape. When you add paint, you can go beyond the wet area to create the precise edge needed.

Always have water at the ready.

WETNESS TERMINOLOGY

ON YOUR PAPER

- **Flooded:** a sheet of water that even obscures the texture of the paper.
- **Wet:** paper is shiny with water, but texture of paper evident.
- **Damp:** a dulled shine, perfect for many techniques.
- **Moist:** shine is gone, but paper still has moisture; a dangerous time to work.

ON YOUR BRUSH

- **Sopping:** brush goes directly from water to paper; OK if you are pre-wetting your paper.
- **Wet:** brush is wiped once or twice on the edge of the water container.
- **Damp:** after wiping the brush on the edge of the water container, excess moisture is squeezed or pulled out. Brush can still moisten the paper.
- **Moist:** only enough moisture remains to hold the brush in shape. Great for lifting color.

HYDRODYNAMICS: THE LAW BEHIND IT ALL

One of the most important things for new painters to learn is that there are different degrees of wetness, and that these differences determine the effect we get when they meet. This is the basis for most of the techniques we use. Whether the technique works or not depends on your awareness and ability to control the amount of wetness involved.

There is only one law of physics to remember: *When two unequal bodies of moisture meet, the greater wetness will always flow into the lesser.*

It doesn't matter where or what they are. For example, paint or water will flow off a brush onto a surface if the brush is wetter than the surface. Paint or water will flow from the surface onto the brush if the brush is drier than the surface.

You will not get much flow if the two areas are of similar wetness. Only when there is one that is much wetter than the other will there be flow.

Often the flow is from a large wetness on the paper into a less wet area beside it, put down with another brush. We call this "fading out," or "softening an edge" (see pages 22–23).

Below are examples of textural and blending effects created by just one aspect of hydrodynamics: adding water or paint to a damp/painted surface. There are many more for you to discover, as you will see later in the book.

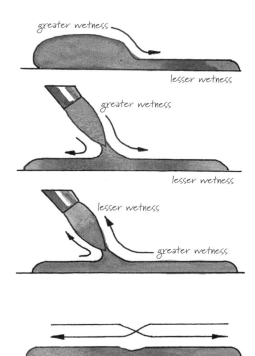

HYDRODYNAMICS

Hydrodynamics: the direction of flow is always from the greater wetness to the lesser wetness.

Strokes of pale blue were laid onto damp reflections using the edge of a flat synthetic brush.

Background color was quickly painted beside and between the wet color of the flames and allowed to mingle.

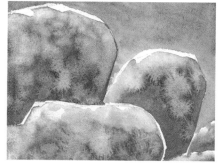

Water was dropped with a brush tip onto the damp blue-brown paint on the rocks.

Fading Out

There are many occasions in watercolor when you want to fade out or soften the edge of a colored area. For example, you may want more eye movement throughout your picture. You can do that by softening a few of the hard edges on shapes as it's being painted. Fading out is like added a passageway or invitation for the eye to move on. Clouds are a perfect example of shapes that have some hard and some soft edges.

We can also use this technique to make the viewers see only what we want them to see.

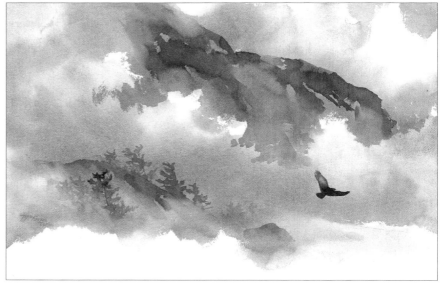

FADING OUT FOR EASE OF TRAVEL
Fading out an edge is like opening a visual gateway on a shape. Your eye sees the hard edges but still moves freely about the picture.

FREEDOM
15" × 22" (38cm × 56cm)

A
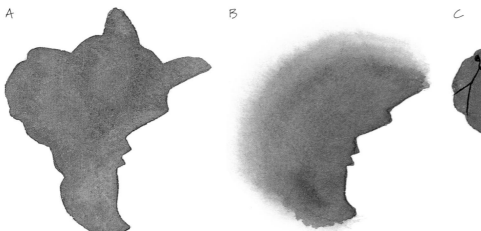
B

C

FADING OUT TO CONTROL WHAT THE VIEWER SEES
Fading out edges can direct the viewer's eye to see what you want it to. The eye focuses on hard edges; therefore, if I don't want the viewer to notice an edge, I will fade it out. For example, if I paint an irregular shape on the paper (figure A) you may not know what it is until I fade out one side or the other (figures B and C).

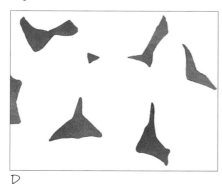

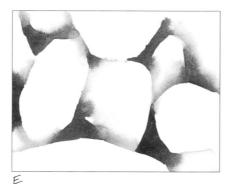

THE TRICK OF PERCEPTION
This trick of perception is used continually in watercolors. In figure D are some random marks. In figure E you can see what they mean once I soften some of the edges, or, in other words, tell you where not to look. Fading out is also the method to use to model a shape with shadows.

D

E

GETTING IT RIGHT

As mentioned on page 21, if two bodies of unequal moisture meet, the wetter area will overflow into the drier area in order to balance out the system. So, if you want an area to fade out, you must use a brush that is less wet than the painted area.

There are a few other things you must also get right. One is the direction in which you move the damp brush. Follow the shape or contour of the painted area. Don't reach into the paint and drag out color.

Also, be careful how close you get to the wet paint with the damp brush. All you are trying to do is lay down a damp strip that will attract the wetter paint, so just tickle the edge of the paint. It may take several passes with the damp brush in order to moisten the paper enough. Once the paint begins to move, make your strokes farther and farther out.

It's best if you have your damp brush ready to go as you're laying in the area you want to fade out. If your damp brush is working as soon as the paint is down, you're more likely to succeed. Remember that the drier the paint gets, the less willing it is to flow and the harder it is to get a less wet brush to move it. Therefore, get to fading out quickly and, by all means, do some practicing.

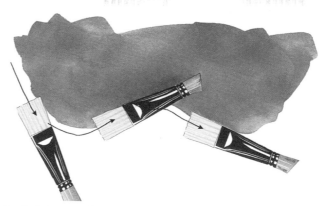

DOS AND DON'TS OF FADING OUT
Remember that your brush must be less wet than the painted area you're trying to fade out. Follow the contour of the wet paint, just tickling the edge of the painted area.

Don't reach into the paint to pull it out.

If you go too far into the paint, your damp brush will just soak it up.

READY TO FADE OUT
Have a damp brush ready before you even put the paint down.

Graded Washes

A *wash* is a solid sheet of color. A wash over a previously painted surface is called a *glaze*. A *graded wash* is a wash that changes in hue, value, temperature or intensity from one section to another. A graded wash does not have to be developed along a horizontal line as shown on this page. It is possible to have one that is curved or circular (see pages 121–122). You will use all of these techniques in this book.

THE 15-PERCENT SOLUTION

This is a method that I use because it works so quickly on a graded value wash. If you want to smooth the gradation even more, tilt your board slightly as you work. Use a large 1½-inch to 3-inch (38mm to 75mm) flat wash brush and any color.

GRADATING ONE COLOR INTO ANOTHER

You can also gradate one color into another by playing both ends against the middle.

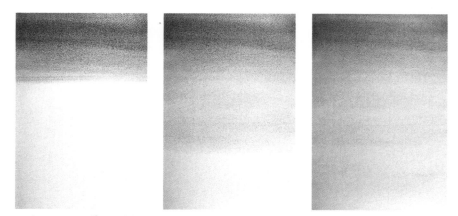

1. Make a Few Strokes

Load your brush with color and paint a couple of strokes across one edge of your dry paper.

2. Reduce the Pigment by 15 Percent

Quickly dip the brush in your water container and wipe it on the container's edge twice. This will reduce the concentration of pigment on the brush by about 15 percent. Now make a few more broad strokes across the paper starting on top of the last one put down.

3. Finish Laying the Graded Wash

Work your way down the paper, repeating the dip-and-wipe process. To fade the color faster, make fewer strokes between dips. To fade more gradually, wipe the brush against the edge of the water container only once.

1. Lay Down the First Color

Paint the first color on the top two-thirds of the paper using long, horizontal strokes.

2. Lay Down the Second Color

With a fresh brush, paint the second color on the bottom of the paper and work your way from the bottom up toward the first color.

3. Blend the Colors

Continue painting the second color right over the first one until you're about one-third of the way into it. Keeping your brush on the paper, reverse direction. Move back and forth until the colors blend.

Palette and Paper

YOUR PALETTE

A palette is more than a place to park your paints. The physical design greatly affects the way you paint.

THE ANATOMY OF A GREAT PALETTE—WHAT TO LOOK FOR

1. **Big wells that will let you access your paint with large brushes.** If you wish to work more freely and spontaneously, you will want to use large brushes. Your palette should have large wells to accommodate them.
2. **Flat wells.** Sloped or basin-type wells allow dirty pigments to accumulate around your clean paint. Flat wells allow dirty pigments to run off your paint.
3. **A large mixing area.** You need plenty of room to mix all the color you need.

PAPER

There is not room in this book to delve into every type of watercolor paper on the market. All I can give you are some basic guidelines for finding the paper that best suits the way you want to work. It will involve some experimentation on your part.

First, let me point out that eight out of ten times it's the *paper* that determines the success of your painting. High-quality paints and brushes, fancy brushwork and a smashing color scheme won't do a bit of good without a suitable surface. What you are working can make the difference between success or failure.

That means that you need to pay attention to your paper. It means that you shouldn't scrimp when buying it. The most common mistake that new beginners (and eternal beginners) make is using cheap paper. They figure that if they are just beginning, they can make do with the cheap stuff. Wrong. When you are beginning, you need all the help you can get. It's like the fella who takes up skydiving and figures that since he's just beginning, he can make do with the cheapest parachute he can find. Give yourself a break. Buy quality paper.

HOW DO I RECOGNIZE QUALITY PAPER?

Good-quality paper should be 100-percent acid-free (pH neutral) rag (cotton), mould-made or handmade. The acid-free quality will help it endure the test of time.

There are many brands on the market that meet this criteria. Less expensive papers are invariably made on machines using wood fibers (cellulose) which are put down in layers to build up the thickness. Not only do these cellulose fibers not hold moisture for very long (a critical aspect of many techniques), they will also separate if scrubbed, taped or masked. As would be expected, some mould-made papers now contain treated wood fibers (cellulose), or synthetic (polyester) fibers. You be the judge.

You will need a paper that holds moisture long enough for you to perform whatever techniques you wish. Cotton fibers have the greatest water retention. The thicker (heavier) papers will allow you to work at a technique longer because they hold more water and dry more slowly and consistently, with less warping in the process. The thickness of the paper may affect surface quality in some brands. While most 300-lb. (640gsm) papers tend to be impervious to any technique, the same cannot be said of lesser weights for all brands. That means that you must experiment with several brands in this lighter weight range to find the one that best suits your way of working.

You will find many types in the 140-lb. (300gsm) range that are quite suitable, especially for half-sheet paintings or smaller. Test a single sheet, though, before you buy a truckload.

Watercolor paper comes in three common surfaces:
- Hot-press (smooth)
- Cold-press (medium textured)
- Rough (heavily textured)

Texture affects the appearance of brushwork and detail, so experiment here, too. I typically stick with the middle-of-the-road option: cold-press.

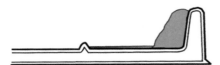

PLACING PIGMENT
Squirt your paint out along the back wall of the well so that it stays well above the dirty pigments below.

TIP

If you have $100 to spend on painting supplies, spend $40 on paper, $35 on paint, and $25 on brushes.

Negative Painting

Whenever you save a light shape by painting around it with a darker color, you are negative painting.

UNDERSTANDING THE PROCESS
I have a small piece of paper and a felt marker with which to make the letter "G."

One way to do this is to print "G" on the paper (top right). Another way is to black out everything that isn't "G" so that what is left makes the letter (bottom right).

A LITTLE PRACTICE
Try writing your own name using a ballpoint pen and scrap paper. You don't have to work large to see the effect. What you are doing is creating words without actually writing them. If you can do that, then you can paint in the negative, because negative painting is the same thing, only with objects. You are making the shape of an object without actually putting paint on it. After mastering words, try simple objects like a house, ladder, bird, flower, and so on. All you need is a ballpoint pen.

WHAT ISN'T THE LETTER
If I wanted to do my whole name, I would first divide a long rectangle by the number of letters in my name and then black out what isn't each of the letters. The black represents the negative shape or space.

CREATE BRANCHLESS TREE TRUNKS
Using any dark-colored paint and a no. 8 or no. 10 round brush, make vertical strokes that represent the negative spaces between light-colored tree trunks. Try to vary the sizes and shapes of the dark lines and light spaces left between, kind of like a freeform bar code.

CREATE TREE TRUNKS WITH BRANCHES
Try again, only this time imagine that some of the light spaces branch into sloppy "Y" shapes. Make a row of these where again the sizes, angles, shapes and spacing are varied.

FILL OUT YOUR FOREST
Now, working within only the dark negative shapes, add a second set of even darker marks to define the space between more tree trunks deeper in the forest. It might help to lightly sketch these first.

IMPROVE YOUR CHANCES OF SUCCESS WHEN NEGATIVE PAINTING

1. **In the beginning, allow lots of space and room to grow.** In the exercise on page 26, you may have noticed how crowded things became when trying to indicate the negative shapes for trees farther back. Conclusion: when you are going to have several layers of negative painting, always start with large spaces around a few close shapes. If you try to save (go around) too many small shapes at the beginning, it becomes difficult to paint meaningful shapes at deeper layers.

2. **To increase the illusion of depth and add interest to your composition, make the transition into the background a gentle one.** You do that by slowly darkening your layers of color. If you go dark too quickly, it becomes difficult to go darker with subsequent layers. In reality, there is no need to mix darker and darker colors for each layer. Since these are transparent paints, two layers are twice as dark as one. Therefore, using approximately the same value for each layer will cause a natural darkening as layers build up.

3. **Be careful with your color choices.** If you layer one complementary color on top of another, you will dull that layer and all subsequent layers. When negative painting, you are always safe layering colors that are close to each other (analogous) or that aren't direct complements.

4. **Remember that it is permissible to sketch your objects before painting the spaces around them.** With experience, the amount of sketching will decrease as you let each mark tell you were to put the next.

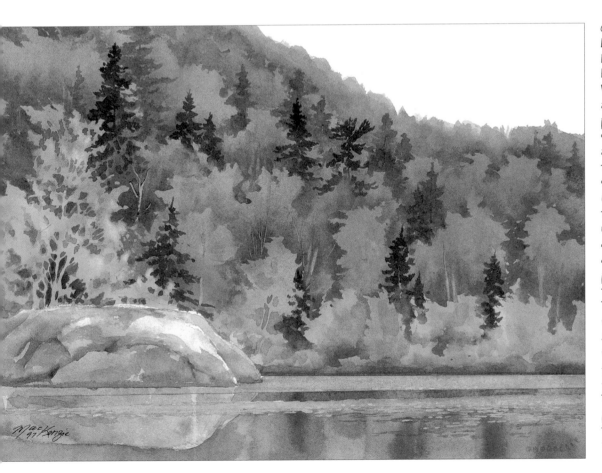

OVERLAPPING LAYERS IN NEGATIVE PAINTING
Whenever shapes are overlapped, part of each shape is positive and part is negative. In this hillside scene, the lighter positive treetops and branches are defined by the darker negative parts of the trees behind. This dark green was sponged around what I wanted to leave for trees, then faded upward. For more on this process of painting trees, see pages 124–125.

Masking

Masking may not have the same appearance as negative painting, but it has the same goal—preserving a lighter shape by painting around it. The two types of masking material that I use most are brown plastic packing tape and masking fluid.

I use the tape for large shapes or ones with precise edges. I use masking fluid whenever I have some small, irregular, intricate shapes or ones with less precise edges to save.

Sometimes when I have a large area to protect that has irregular edges, I will use tape for the central core and masking fluid around the edges. (See pages 67–68 for an example of this method.)

USING MASKING FLUID
Masking fluid is liquid latex that can be applied over a shape to preserve it. Once dry, paint will not penetrate it. After the paint is dry, the dried fluid can be removed by rubbing with your fingers, an eraser or rubber cement pickup.

That's the theory, anyway. In reality, masking fluid *can* let paint through if it has been applied too thinly or had air bubbles in it during application because you shook it before you applied it. (The bubbles later break to let paint through.)

Use tinted masking fluid (such as the blue-gray types) so that it can easily be seen on the paper. Masking fluid can be applied with sharpened sticks, a sponge, a palette knife, a paintbrush or a brush handle. If you use a brush, make sure to protect the bristles by soaping them first and then washing well with soap as soon as you are finished.

USING PACKING TAPE
This technique does not work on machine-made papers or some of the

CUTTING THE TAPE

In order for packing tape to work for masking, you must be able to cut it and remove it easily. A very sharp knife is a must. I recommend small razor knives with the snap-off blades. Use the slot in the handle cap to snap off a section of the blade. The blade must be able to cut the tape with the least amount of pressure. If you have to push hard, you will go through the tape and right into the paper.

To remove tape from the paper, carefully lift a corner with your knife and then, pinching it against the blade with your other forefinger, lift upward. Sometimes warming it with a hair dryer eases the lift.

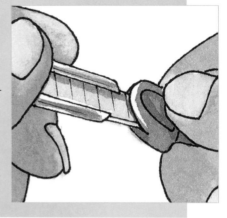

Packing tape: You know the stuff.

more expensive softer types. Test your paper first to see if the tape lifts paper when removed. I've found that Arches paper works best with this material, but you can experiment with various brands. I recommend using the brownish tape which is translucent instead of the transparent type which is hard to see on the paper. I also recommend buying the cheapest (thinnest) brand, which will follow the texture of the paper better than heavy-duty tape.

SPRAY AND APPLY
Here, masking fluid was applied to a water-sprayed surface with the edge of a palette knife. the fluid spread rapidly every time it hit a water drop.

PAINT AND LIFT
When the masking was dry, darker colors were painted over it. When they were dry, the masking was removed.

Combining Masking Materials

This demonstration outlines the procedure for applying packing tape and masking fluid. I suggest that you practice with each before diving into a complex landscape. Please note how the razor knife should be held when cutting the tape.

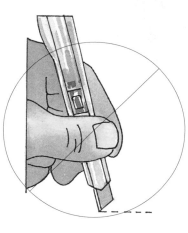

HOLDING THE KNIFE PROPERLY
To make this work, you must hold the razor knife like a butter knife so that as much of the blade as possible is cutting the tape. If you hold it upright like a pencil, all you'll do is tear the tape. It's like trying to cut with a pin.

1. Apply Tape

Cover your sketch in rows of overlapping tape. To cut the tape, simply poke it with your knife and it will break off easily. Only push the tape down lightly at this point.

2. Remove Surplus Tape

Remove surplus tape by lifting the edge with your knife and peeling it up. Firmly press down the remaining tape. Apply masking fluid for intricate or irregular shapes like twigs.

3. Paint

After the masking fluid is dry, paint the background.

4. Remove Masking Materials

When everything's dry, remove the tape and masking fluid. You can now paint the saved areas.

Painting With Palette Knives

It is important that the knives you use for painting have good stiffness, offset handles and a variety of tips. A wimpy blade won't push paint. An offset handle allows you to access and mix your paint more easily and to use your knife on its side. Having knives with tips of different roundness will allow you to make lines of various widths.

If you are going to paint with your knife, it must be cleaned of all old paint, oxidation and body oils. To do this, scrub the bottom of the blade with a wet piece of 250- to 400-grit waterproof sandpaper. Use lots of water. New blades have coats of varnish that require extra scrubbing to clean. Once a blade has been thoroughly cleaned, it only takes a quick touch-up to remove oxidation or body oils before each use.

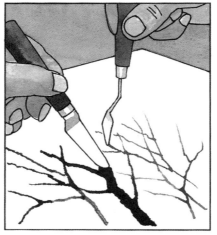

APPLYING PAINT
To apply paint, first load your knife with paint by placing it face-down in a puddle of concentrated color on your palette. (The color should have an ink-like consistency.) If color does not stick to the entire bottom side, the knife is not clean enough. Once loaded, hold the knife almost vertically and drag it across your paper. The roundness of the knife tip determines the line width.

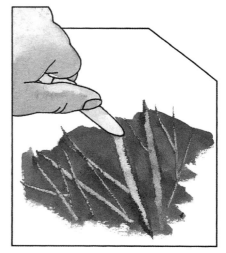

SCRAPING PAINT
To scrape or push paint back, you need as stiff a blade as possible, which means that you may have to support the blade with your thumb. This works best when the paint is just beginning to lose its shine.

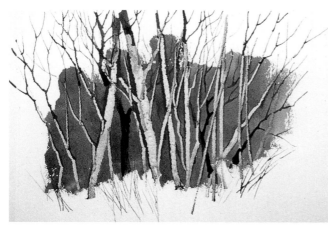

TREE TRUNKS AND LIMBS
I started with a small patch of concentrated color on my watercolor paper. While the paint was damp, I started at the bottom and scraped upward to make tree trunks. I varied the size, position and shape of the lines.

The knife carried some paint (trunks) above the patch. Again using my palette knife, I applied some concentrated color to create more tree trunks and smaller branches beyond the original patch.

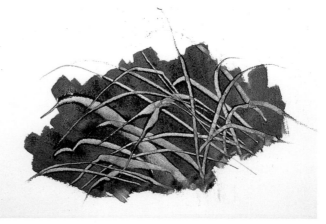

EXPERIMENT WITH STAINING COLORS
Scraping paint can teach you quite a lot about staining and nonstaining colors. Here I laid down a patch of Phthalo Green and Phthalo Blue and immediately painted over it (and mixed into it) with Burnt Sienna, a nonstainer. Once the area had dried to damp, I scraped back the color. The green and blue stained the paper, giving the blades of grass some subtle color.

Painting With a Sponge

Painting with a sponge can create unique, useful textures, but it's also a great way to lay down color fast. A sponge can carry a lot of moisture and pigment. Once the paint is applied, it will also stay wet for a longer period, so you can practice other techniques like scraping, spraying with water, adding salt, etc.

The best type of sponge to use is cellulose (plant fiber) because it holds more paint and releases it more consistently than a plastic sponge. The holes are also more varied in size.

Because they stiffen as they dry, cellulose sponges are usually packaged in a plastic bag with a moisturizer. Cellulose sponges come in blocks and can be found in the housecleaning or automotive section of your grocery store.

When you're ready to use your sponge, dip it in water and then mix paint on your palette. Unless you fancy colored fingers, I recommend wearing a latex glove; this process does bring you in direct contact with the paint.

It's very important that the sponge is well loaded with moisture (the amount of pigment you need will vary, of course). To make marks on your paper, touch the sponge to the surface lightly. Too much pressure obliterates detail. You can touch with the full face, the tip or an edge of the sponge. Each position produces a different mark. Create shapes by building up your marks.

SLICE
Slice off a ¾-inch (19mm) thick slab with a utility knife. Try to cut so the end grain is in the face of the sponge; the sponge will be easier to tear this way.

TEAR
Tear the sponge slice into smaller pieces. Pick off the square corners and straight sides of each of the pieces.

SHAPE
A leaf shape works well for applying different marks.

APPLY
You can apply paint using the side or the tip of the sponge.

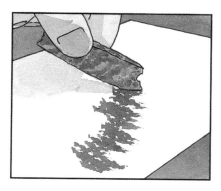

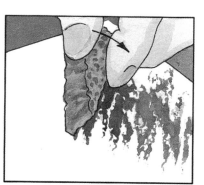

A Treasury of Techniques

The following are but a handful of textural and blending effects that you can get with watercolors once you learn to control the processes and tools discussed in this chapter.

Take time to try these and, by all means, experiment on your own. You will see many of these again in chapter three.

DROPPING WATER INTO DAMP PAINT
Water was dropped from a brush along the top edge of the hill while the paint there was still damp. Tilting the board allowed the water to leave light streaks.

FADING OUT WITH A SPONGE
An area that has been sponged, such as this tree line, can easily be faded out for effects such as fog because the paint goes on quickly and stays wet longer.

DROPPING WET COLOR INTO WET COLOR
Lighter color was dropped into damp forest color. The dark evergreens were added while the surface was still damp. The foreground was created using negative painting.

SPONGING ON TEXTURE
A sponge can add texture to objects, like the moss on these rocks.

SPATTERING ON PAINT

I sprayed the surface with water first, then spattered paint with a toothbrush. Packing tape applied beforehand protected the surrounding areas. Try this technique for rocks.

 

MOVING AND REMOVING COLOR

Using the edge of a damp, flat synthetic brush, I moved and lifted out paint from the dark patch of grass.

APPLYING PAINT ON A PARTIALLY WET SURFACE

Lacy vertical marks were made with the side of a wet hog-hair brush (see page 74), then a dark green was applied with a loaded sponge. This color spread rapidly into the wet areas. A few trunks and branches were added to suggest a backlit forest.

NEGATIVE PAINTING

After laying down the background in light colors, I added trees by painting the negative space using a sponge and a small brush with darker color.

APPLYING PAINT WITH A PALETTE KNIFE

After spraying the paper with water, I applied paint with the edge of a palette knife.

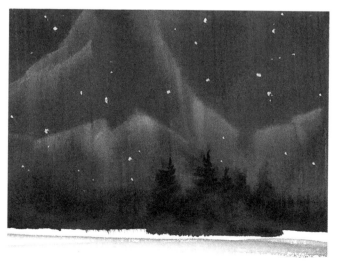

LIFTING PAINT WITH A DAMP BRUSH

While the color was still wet, I lifted it with the edge of a damp, flat synthetic brush. With this technique, be careful to keep the brush clean and not wetter than the surface.

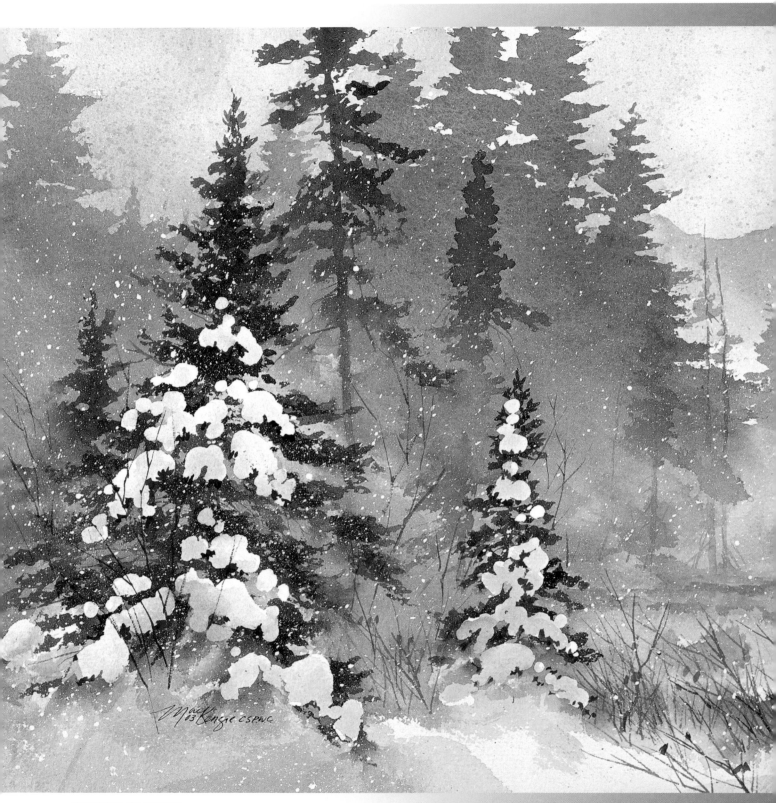

WINTER CLOSING
15" × 22" (38cm × 56cm)

Composing 2 a Landscape Painting

Gaining control of your composition is the essence of becoming an artist. Taking responsibility for how all the parts and pieces of your picture are arranged and depicted is what sets you free.

Let's get it straight: There is no shortcut or sure-fire formula for putting together pictures.

We can study the Masters and schools of art and apply what knowledge we can from them, but in the end we will realize that they were simply a reflection of their times. Composition has always been a measure of artistic freedom or lack thereof, and as such, is an evolving process. It reveals the knowledge, abilities, likes and dislikes of the individual artist at the time. In the end, what you will learn from art history and hands-on experience is that the indomitable creative spirit is universal, timeless and unique to each of us. The tremendous diversity of visual expression that we are heir to is proof that there is more than one way of doing things.

It may seem as if I am trying to avoid revealing all the secrets of composition, but I'm not. In fact, shortly I will share many of them. I know that some of you want and need some rules and guidelines to follow at this point and that is fine, so long as you realize that they are only crutches, and borrowed ones at that. Sooner or later you'll need to—no, want to—give them up. In time and with practice, you will reach the point where you won't want to follow somebody else's way of doing things.

The process of composing is an exercise in self-discovery. The more you learn to rely on yourself and your own intuitive preferences, the faster you'll gain artistic independence and freedom.

How Do I Go From Painter to Artist?

Composition is the process of arranging shapes, lines and colors "in order to convey your visions or ideas. But it goes beyond that. There are things, almost magical, that can happen with the arrangement of these elements. But this kind of knowledge takes time and experience to acquire. That's what this journey is about.

I have a friend who referred to the process of composing a picture as "plotting" her picture. She might be closer to the truth than she knows. There might be something slightly sinister in the mind games, optical illusions and visual trickery you play on the viewer, as if "plotting" the great crime of the century. (So, what do we do with the evidence? We hang it.)

The journey you are on is about learning to rely more and more on

The primary source of quasitonic vericulum is only comparative to the equilibrium of narrative and humanological conquests into supraspastic revelations of inter-garafraxic normalcy. Are you getting all this?

No, but I **am** getting a shovel.

IT'S LESS COMPLEX THAN YOU THINK... REALLY Composition may seem like a mysterious bunch of contradictory and confusing picture-making rules concocted by a bunch of obscure dead artists or obtuse live ones... but it doesn't have to be.

our own intuition and knowledge base and less and less on others.' It's about recognizing that your limitless creative and imaginative powers make you far more than a biological camera. But being creative and imaginative can be hard to do because it means acknowledging

your own independence and self-worth. For many of us, that's a big hurdle. For some of us, it is a dangerous one as well.

"But I might make a mistake."
So what? You are probably the only one who knows or even cares. Do you really think that others are concerned with what you do on your pieces of paper? They've got their own pieces of paper to worry about. As for the critics who don't even try—learning to ignore them is the kindest thing you can do for them.

ART IS "ME" MADE VISIBLE Growing from painter to artist is about honoring the child of the universe within you who just wants to play.

Meanwhile, try to remember this:
You have always known how to compose pictures.

You did it as a child and you never forgot.

What you have lost is the memory and nerve to follow your instincts when making a picture.

What you have temporarily forgotten is how to play.

What you grew instead was an ego that demanded protection from embarrassment at all costs.

But it is time to take back command, responsibility and freedom for your compositions
—because no one else will.

STARTING DOWN THE ROAD

The evolution from painter to artist occurs on many fronts simultaneously.

It's important to recognize that a primary method of learning is imitation. Many of the techniques we're capable of today are a direct result of copying someone else in varying degrees. It's a way for beginners to gain confidence; it allows them the experience of painting without having to worry about technicalities.

However, art is ultimately about *self*-expression. Somewhere between relying on others and artistic freedom is a path that we all walk.

As convenient as it is to rely on others, it is imperative that over time you break away from using other people's things—their paintings, their photos, their reference material—to using your own. This can be a long process, so the sooner you make the decision to pursue self-expression, integrity and uniqueness, the sooner you'll be able to call yourself an artist.

WEANING YOURSELF

To wean yourself of other people's materials, ask yourself, "What is it that I like about the painting? What is it in the way the artist handled the subject that appeals to me?" This is probably the aspect you want to imitate. Anything else can be altered and adapted.

Start building your own database. Start collecting pictures that can be used for reference. Start taking your own photos. By all means start sketching, because there is no better way to improve your ability to see than to draw.

OK, we have to decide—are we going to be painters in Copyville or artists in Uniqueville?

Letting go means taking command.

USING YOUR OWN REFERENCE MATERIAL

As you gradually build and use your own photo/sketch reference base, remember you can always:

- **Eliminate** stuff. Sometimes less is more.
- **Simplify** stuff. Would fading out or obscuring certain parts produce a stronger composition? Would a few details be more appealing than having everything in detail?
- **Combine** bits of material from several photos or sketches into one picture.
- **Rearrange** objects or group isolated objects for stronger compositional units.
- **Adjust** the colors to suit your own tastes or the mood you want to create.
- **Change** the atmosphere, season, time of day or direction and quality of the light source.
- **Add** movement to your work by positioning shapes and lines at an angle to the picture frame. Set up paths for the eyes to follow.
- **Zoom in** on a single item or area of interest, or expand different aspects of an idea.
- **Multiply** a single object into a full composition, such as creating variations of a single flower to form a bouquet.

Throughout this stage, you will undoubtedly become more and more familiar with the language of art (the elements and principles of design) and use it to strengthen your composition. However, you will use intuition more and more to confirm various aspects of your composition. That is, "Does it feel right?"

SELF-CRITIQUING

As your experience, self-confidence and art knowledge grows, so does your desire and ability to self-critique. You will automatically ask yourself questions such as:

- Will the viewer be able to see clearly what I want them to see? (i.e., Am I close enough to the subject, Are the colors, sizes, contrasts and movements effective?)

- Have I put visual energy and excitement into my picture to hold the viewer's interest?
- Have I left areas of mystery in my work to stimulate the viewer's imagination?
- Have I created an effective mood or atmosphere in my work that enhances the subject?
- Have I chosen an interesting point of view?

A WEE BIT O' ART KNOWLEDGE WON'T HURT

When planning a composition, an artist has only so many tools to work with. We call these tools the "elements" of design. They are color, line, value, shape and form.

With these tools, an artist is able to create certain effects within a painting. These effects are referred to as "principles" of design. The principles are mood, perspective, balance, variety, unity, contrast or emphasis, rhythm and movement. For example, you may decide to use colors to create mood, or aerial perspective, or variety. In a similar way, lines could create linear perspective, movement or rhythm.

Start using your own reference base and you'll grow as an artist.

Trust your ability to self-critique.

COMPOSING LANDSCAPES FROM WITHIN

This means looking within yourself for ideas of what to paint. It means using your imagination, memory and experiences along with art knowledge to develop a painting. Art knowledge is applied in a sub-conscious, intuitive way as you give priority completely to what "feels right." Even if you are working from a real scene, your picture will be a reflection of how that scene stimu-lated you. You are now in full control of your composition.

Reference material is now there to support an idea that has come from your imagination, your experi-ences, your memory. Theories of composition are there to confirm your intuition. The landscapes com-posed *from* within have become the landscapes that *are* within. This way of creating will come with time and experience.

FINALLY, THE SECRET

The speed with which you proceed from painter to artist depends on three things: your painting frequency, your painting frequency and your painting frequency. The more you paint, the faster you grow. It's that simple.

WHAT IS INTUITIVE PAINTING?

You cannot will creativity, or insight, or intuition. All you can do is approach your work with a daring and open mind that will invite them in.

When a viewer looks at a painting, they don't realize that they are really looking at the result of numerous intuitive deci-sions made by the artist throughout its entire creation. Decisions, such as how the subject should be portrayed or transformed to suit their vision; drawing upon their subconscious inclinations to design their layout; listening to their inner voice when they choose their colors and make technical choices; are all intuitive acts that are well hidden in the final work. Viewers are not aware of the communion that took place between the medium and the artist's intellectual, physical and spiritual capacities.

I do not believe, therefore, that "intuitive" painting is a unique style, appearance or procedure, but instead simply describes the frame of mind the artist was in during the picture's creation. I don't think that select schools of painting were given sole ownership of intuition. I believe that it is there for us all to use, regardless of how we choose to express ourselves.

DISCOVERING THE LANDSCAPES WITHIN

You did not come into this life as a team. You came as an individual—to explore, experience and grow your way through all it has to offer. Making pictures is simply a way for you to express the perceptions, feelings and values of that individual point of view.

In your own Bosom you bear your Heaven and Earth and all you behold; tho' it appears Without, it is Within, in your Imagination...
—William Blake

Color Characteristics

When painting, the least useful information about a color is its trade name. What is more useful is knowing that color's characteristics. There are four characteristics of color you should be familiar with: hue, value, intensity and temperature. When the paint starts flying, you'll find yourself asking, "Does my picture need a dark or light color there? Should it be warm or cool? Should it be pure (intense) or dulled? What hue will I use?"

Paint characteristics—the effect of a pigment rather than its color—are also important. You can learn more about that on page 13.

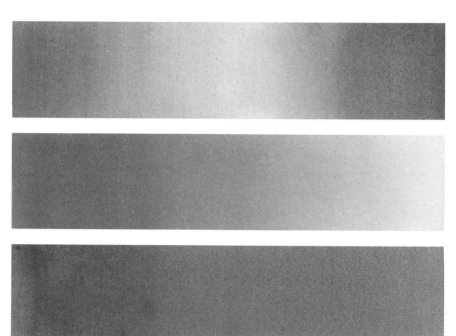

HUE

Hue is the name of the color in its purest and simplest form—red, blue, green, blue-green, yellow, etc. It's what best describes its location on the color wheel (see the next page).

VALUE

Value is the lightness or darkness of a color. In watercolor, you lighten a color (or create a tint) by adding water. To darken a color, mix it with another dark color. You can also darken with black or blackened colors (such as Indigo or Sepia), but it's easy to kill a color that way.

INTENSITY

Intensity is the brilliance or saturation of a color. A color can be dulled—never undulled—by adding its complementary color (the color opposite of it on the color wheel). Mixing complementary colors in the right degree produces different grays.

TEMPERATURE

Temperature is the warmth or coolness of a color. About half the colors on the color wheel can be grouped into a warm family (reds, oranges and yellows) and half into a cool family (violets, blues and greens). Red-violet and yellow-green can be either warm or cool depending on the neighboring color.

Just to confuse things, each hue has a warm or cool bent depending on whether they slide slightly around the color wheel towards the red-orange (hottest) or blue-green (coolest) colors. So, it is possible to have a cool red or a warm blue by adding a touch of blue to the red or a touch of red to the blue.

Color Wheel

This wheel indicates the relative placement and temperature of the paints I regularly use.

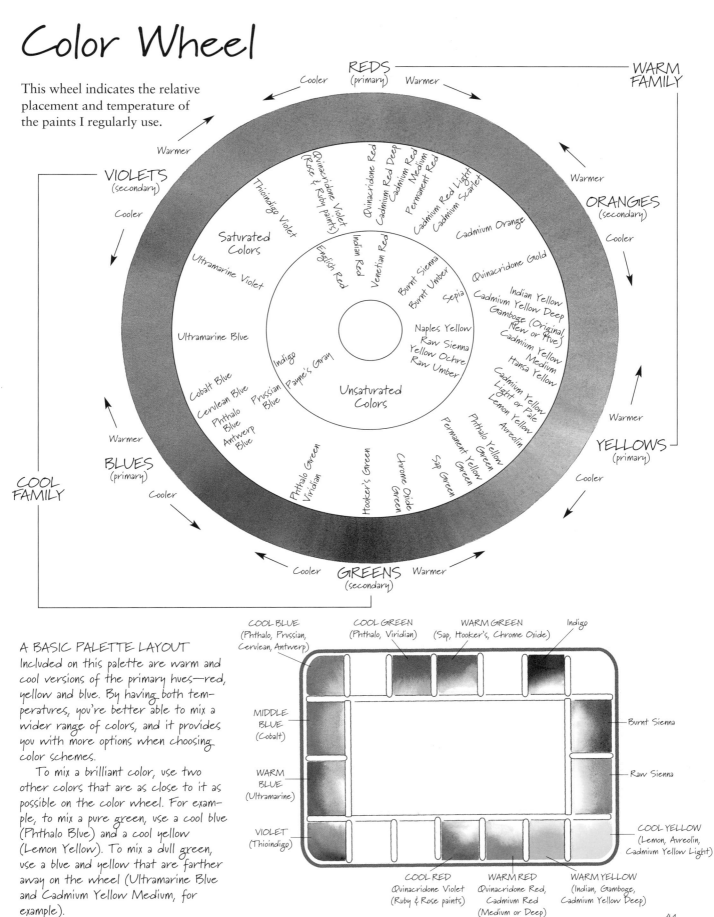

REDS (primary)

Cooler ← → Warmer

WARM FAMILY

VIOLETS (secondary)

Warmer

Cooler

ORANGES (secondary)

Warmer

Cooler

Thioindigo Violet

Quinacridone Violet (Rose & Ruby paints)

Quinacridone Red
Cadmium Red Deep
Cadmium Red Medium
Permanent Red
Cadmium Red Light
Cadmium Scarlet

Cadmium Orange

Quinacridone Gold

Saturated Colors

Ultramarine Violet

English Red

Indian Red

Venetian Red

Burnt Sienna
Burnt Umber

Sepia

Indian Yellow
Cadmium Yellow Deep
Gamboge (Original, New or Hue)
Cadmium Yellow Medium
Hansa Yellow

Ultramarine Blue

Naples Yellow
Raw Sienna
Yellow Ochre
Raw Umber

Unsaturated Colors

Cobalt Blue
Cerulean Blue
Phthalo Blue
Antwerp Blue

Indigo

Prussian Blue

Payne's Gray

Cadmium Yellow Light or Pale
Lemon Yellow
Aureolin

YELLOWS (primary)

Phthalo Green
Viridian

Hooker's Green

Chrome Oxide Green

Sap Green

Permanent Green

Phthalo Yellow Green

BLUES (primary)

Warmer

Cooler

Cooler

Warmer

COOL FAMILY

GREENS (secondary)

Cooler ← → Warmer

A BASIC PALETTE LAYOUT

Included on this palette are warm and cool versions of the primary hues—red, yellow and blue. By having both temperatures, you're better able to mix a wider range of colors, and it provides you with more options when choosing color schemes.

To mix a brilliant color, use two other colors that are as close to it as possible on the color wheel. For example, to mix a pure green, use a cool blue (Phthalo Blue) and a cool yellow (Lemon Yellow). To mix a dull green, use a blue and yellow that are farther away on the wheel (Ultramarine Blue and Cadmium Yellow Medium, for example).

COOL BLUE (Phthalo, Prussian, Cerulean, Antwerp)

COOL GREEN (Phthalo, Viridian)

WARM GREEN (Sap, Hooker's, Chrome Oxide)

Indigo

MIDDLE BLUE (Cobalt)

Burnt Sienna

WARM BLUE (Ultramarine)

Raw Sienna

VIOLET (Thioindigo)

COOL YELLOW (Lemon, Aureolin, Cadmium Yellow Light)

COOL RED Quinacridone Violet (Ruby & Rose paints)

WARM RED Quinacridone Red, Cadmium Red (Medium or Deep)

WARM YELLOW (Indian, Gamboge, Cadmium Yellow Deep)

41

Color Schemes

This is something that you really don't need to know until you have had a few years of painting experience. However, once you want to use colors more effectively, then it is worth browsing through this information.

This is not to say that you have to use one of these traditional color schemes every time you paint a picture. What I am saying is that with the use of a color scheme, your picture will exude a greater sense of harmony and unity, provided you stick to the plan you have chosen.

TIP

Avoid opaque colors in triads and complementary-analogous schemes. They lead to muddy colors when mixed with more than one other color.

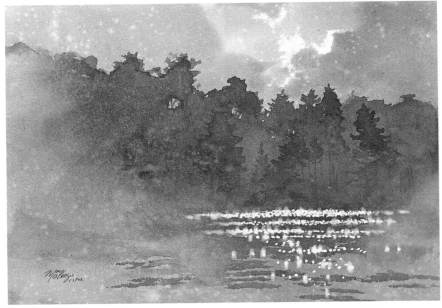

COLOR SCHEME IN PRACTICE
This painting was done with a triad of Permanent Rose, Cobalt Blue and Raw Sienna.

DAVE'S POND
11" × 14" (28cm × 36cm)

MONOCHROMATIC
This scheme uses value differences of one color to create contrast within a picture. For maximum range, start with a dark color.

COMPLEMENTARY
Opposite or complementary colors provide maximum chromatic contrast next to each other. When mixed, they produce a range of dulled versions of each other. A balanced mix produces a gray.

ANALOGOUS
There is bound to be harmony when all of the colors are related to each other. This is a good scheme for emphasizing a particular temperature.

COMPLEMENTARY-ANALOGOUS
You get harmony from the analogous side and balance or accent with the complementary side. Intermixing produces a wider range of dulled colors and grays.

TRIAD
Any three colors in a triangular arrangement produces the widest range of mixed colors and unique grays.

The Quality of Sunlight

It's possible to control different types of sunlight in your picture by controlling shadows, detail and color purity.

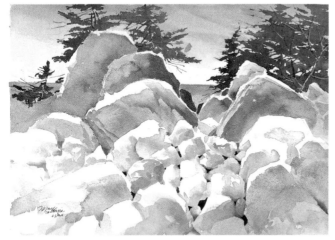

FULL-STRENGTH LIGHT
Under clear, bright conditions, the sky is blue, colors are pure, and edges and some details are sharp. In the brightest sunlit areas, detail is obliterated. Values are extreme throughout. Most color play is found in the shadowed areas.

ACCENT LIGHT
This is when small areas are momentarily accented as the sun breaks through the cloud cover. At sunset, when the sun breaks through heavy clouds, we have the same accent light illuminating the trees, hilltops and clouds in the east. This light adds a real drama to your paintings. Varying values and pure colors adds strong contrast. Evening light can bathe the accented areas in a harmonizing, soft pink-orange glow.

SLIGHTLY HAZY LIGHT
With this type of light, the level of detail and sharp contrast begin to decrease in the distance. The darkest values tend to be in the middle ground and foreground. With decreased light comes a slight decrease in the purity of colors. Now I can show detail, like the moss on top of the rocks.

DIFFUSED LIGHT
With the increased humidity of foggy/blizzard conditions comes a decrease in detail, sharpness and value contrast throughout. Shadows are warmer, softer and lighter. The darkest values are in the foreground. Colors are duller and more subtle.

Light Effects

As artists, we know that we're really only painting what light reveals to us. But it is not sunlight that gives Earth its unique appearance—it's skylight. On the moon, where there is no atmosphere, the light effects are very harsh. It's very bright where the sun shines and very dark where it doesn't, except for a touch of reflected light. On Earth, the atmosphere diffuses some of the incoming sunlight, which in turn lights the whole daytime earth softly and indirectly. We call this skylight, and its condition greatly affects what we see, feel and paint.

LIGHT DIRECTIONS

The pictures below illustrate the characteristics of a sidelit, frontlit and backlit subject. Here the subject, a post and rock, have no cracks, texture or local color to interfere with the light effects.

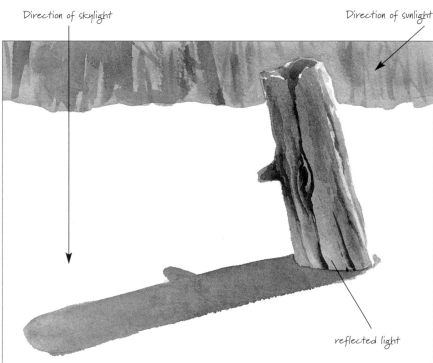

Direction of skylight

Direction of sunlight

reflected light

WHAT DOES SKYLIGHT LOOK LIKE?

Imagine a fence post in the middle of a field of snow on a clear sunny day. The shadow on the back of the post and the one cast on the snow represent the only areas the sun can't reach directly. The source of light here is skylight, and its color is a reflection of the sky color. In this case, it's a cool blue-gray.

As sky conditions (atmosphere) change, so too does the effect of sunlight and skylight.

SIDELIT

One side of the post and rock are left white for sunlight. Shadows on the back side are cool near the top and warmer and lighter near the bottom to suggest reflected light. Cast shadows blend into local shadows. The background is darkest next to the highlights.

FRONTLIT

Here, the sunlight coming from behind the viewer creates shadows around the edges of the rocks and post.

BACKLIT

Light from behind the subject can silhouette or give it light edges. Shadows are cool near the top and show warm reflected light near the bottom.

Creating Atmosphere/Mood

By altering colors and clarity in your painting, you can create distinct types of mood, also referred to as atmosphere. The amount of humidity, snow, rain or smog in the air determines the quality of light that gets through it and in turn the types of colors and details we see. Establishing a distinct mood will bring character to your paintings.

To intentionally create a desired mood, first decide on the dominant *temperature* you want for your picture, then the dominant *value*, then the *clarity* (level of detail). The value (lightness or darkness) and clarity will dictate the light, which will dictate the intensity of the colors in turn.

For example, if I want a warm picture that is primarily light and choose a clarity that is sharp, then I will use colors that are mostly pure. I would also do a lot of wet-on-dry painting for sharpness, show distant detail, and model shapes with shadows and highlights. Sharp clarity implies that the scene is well-lit.

On the other hand, if I choose a clarity that is hazy, then most of my colors will be dulled because of subdued lighting. I'll use lots of wet-on-damp techniques that produce soft edges, and my background shapes will become flattened like silhouettes.

TIP

A center of interest will stand out if some of its characteristics are opposite to the atmosphere.

1 Temperature	2 Value	3 Clarity	4 Intensity	5 Lighting
WARM cheerful vibrant vigorous exciting friendly earthy	**LIGHT (high key)** ethereal spacious optimistic delicate yang	**SHARP** (wet-on-dry painting predominates in all grounds) low humidity distant detail shapes modeled with shadows and highlights crispness	**PURE (vivid)** powerful loud lively clean youthful	Full Strength
BALANCED MIX	**BALANCED MIX**	**BALANCED MIX**	**BALANCED MIX**	Accent or Flood
COOL clean refreshing calming distant restful	**DARK (low key)** mysterious foreboding weight strength closeness dignity power yin	**OBSCURED** (wet-in-wet or wet-on-damp painting predominates in background and middle ground) high humidity limited vision mystery closeness quietness shapes flattened like silhouettes	**DULL (grayed)** subdued conservative mature quality dreaminess subtleness	Diffused

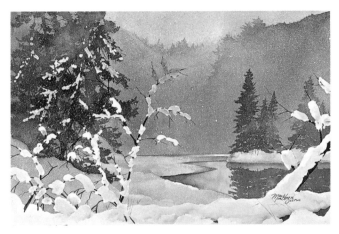

DECISIONS, DECISIONS
These steps will help you understand and develop atmosphere in your pictures. The characteristics of each variable are also indicated.

THE ATMOSPHERE OF THE PAINTING
Despite the snow, this painting evokes closeness, a warmth or coziness, and serene solitude. This is because of the diffused lighting, subdued clarity and warm, dull, midvalue colors.

SUN FLURRIES
14" × 22" (36cm × 56cm)

Perspective

Let me point out first that perspective or perception of distance is only an illusion and not a prerequisite to picture-making. However, that illusion adds dynamics to your work by moving the viewer's eye within and in and out of the picture.

Since most landscape painters want some form of this visual deception in their work, I will review a few of the basics that don't require a ruler.

ELEVATION

Whenever we make a picture or scene, we do so from a particular point of view. The elevation of that view determines what we are able to see. Some things in the view can be seen from above, others from below. To indicate where we want the eye level to be in our compositions, we use an imaginary horizontal line called the "Eye Level Line" (E.L.L.). It is the level of the artist's and viewer's eyes in relationship to the scene.

DISTANCE CHANGES OBJECTS
As things move into the distance, they appear smaller, lose detail and sharpness, and become lighter, cooler and grayer in color.

LINES CREATE DISTANCE
Linear shapes and edges on the surface of the land (such as roads, rivers, canyons, furrows, ridges and waves) will lead you merrily off into the distance.

OVERLAPPING SHAPES
A series of overlapping shapes or grounds will create a sense of distance. Darkening the foreground or showing only part of an object in the foreground will give the viewer the feeling of peering deep into a private world.

E.L.L.

WHAT'S BELOW
A high eye-level line emphasizes what's below. In this case, the emphasis is on the quiet depths of the canyon.

CANYON GLOW
11" × 14" (28cm × 36cm)

46

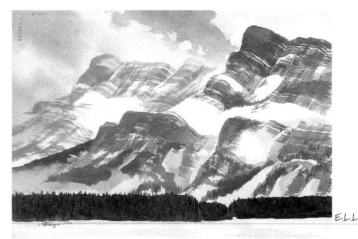

E.L.L.

WHAT'S ABOVE
A low eye-level line emphasizes what's above it. This can be useful for spectacular skyscapes. This painting's E.L.L. reinforces the majesty of the towering mountains.

ALBERTA APRIL
11" × 14" (28cm × 36cm)

EYE LEVEL LINE (E.L.L.)

Unless you are a cubist, there is only one E.L.L. for each picture. Do not confuse the E.L.L. with the horizon, which is where the sky meets the earth. Only if you are looking out over a large body of water or a plain will the horizon be the same as the E.L.L.

Here's an example. Also watch what happens to our sense of elevation as we raise the E.L.L. by adding more distant shorelines to the composition below.

LOW EYE LEVEL
The top edge of a large plain or body of water is usually the E.L.L. The horizon is where sky meets the land.

RAISED EYE LEVEL
Now the E.L.L. is the distant shoreline, and you see more water surface.

HIGH EYE LEVEL
We can see even more of the water's surface as the E.L.L. and the horizon become one.

OBJECTS IN OR ON WATER

LOW EYE LEVEL
If your eye level is low, the objects that are sitting on or protruding from the water's surface—including land masses—will appear stacked up and have fairly straight bottoms.

RAISED EYE LEVEL
As the E.L.L. rises, you'll see greater spacing between the objects. Most importantly, the closer they are to you, the more angle and curvature you will see in their baselines.

HIGH EYE LEVEL
An even higher E.L.L. allows you to arrange the objects into a pleasing layout, like furniture.

Surface Patterns That Lead the Eye

There are often parallel lines (e.g. waves, furrows) or rows of shapes (e.g. clouds, plants) in our environment that we can use to create the illusion of distance if we put them in perspective. We know that if we look down parallel lines, they appear to converge toward some point in the distance. The point at which they appear to meet is called a vanishing point, and that vanishing point is on the eye level line.

THE FAN PATTERN

If you wish to dramatically increase energy, movement and distance, try laying out parallel lines or rows in your picture in a "fan" pattern. To do this, secure your paper to a flat surface and lightly draw a desired eye level line that extends well beyond the picture plane. Pick a vanishing point on that line, and then, using a large ruler, draw light lines across your paper while rotating it on the vanishing point. It is important that the lines that are nearly horizontal are drawn close together. As the pattern fans out, the lines become further and further apart. Please realize that these lines are only guidelines for positioning your waves, furrows or clouds so they'll create the illusion of distance without looking bent out of shape.

With practice, you won't need a ruler. You'll be able to sketch light guidelines freehand with the full sweep of your arm.

TIP

The best way to see the pattern in waves or furrows is to look at them through a viewfinder. Note the angle of the waves or furrows compared to the rectangular opening.

THE FAN PATTERN AND GRADATION Gradation also leads the eye. When combined with the energy and movement of a fan pattern, it becomes even more effective. The types of gradations are endless. Most often a gradation involves color, but you also see gradations in size, shape, pattern and detail.

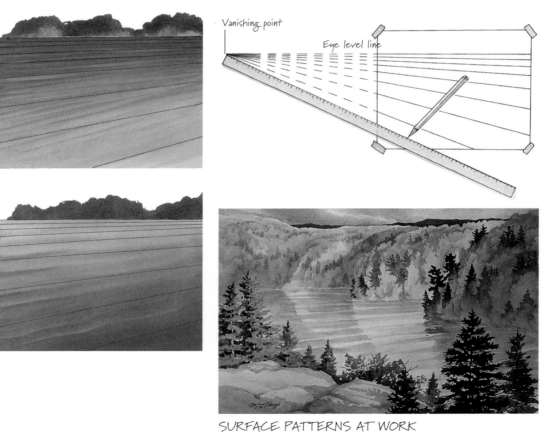

Vanishing point

Eye level line

SURFACE PATTERNS AT WORK
Here is an example of how a fanned surface pattern can lead you into a picture.

VANTAGE POINT
11" × 14" (28cm × 36cm)

THE OLD ZIGZAG GAME

One of the most effective ways to lead the viewer through the picture is with a zigzag pattern. It can have as many turns as you want, but even a couple will do.

Think of back roads, meandering streams and canyons as big, wide zigzags. Make them extra wide in the foreground so that the illusion of distance can be more effective. Using a viewfinder will show you that these things are a lot wider in the picture space than you think they are.

Zigzag patterns are not always sharply defined streams and roads. Sometimes, they occur like stepping stones, in the form of lily pads, clouds, waves or puddles.

OVER THE HILL AND THROUGH THE WOODS

You can give the impression of an undulating and twisting road by not showing all of it, as demonstrated in the exercise below.

ZIGZAGGING A PATH
The zigzagging puddles lead us right across the picture. The reflections unify the puddles.

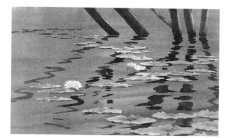

TWO ZIGZAGS
There are two zigzags leading the eye through the painting: the line of the water lilies and the broken reflections of the trees.

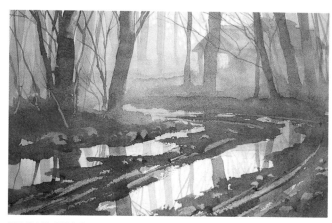

SUGAR SHACK MORNING
11" × 14" (28cm × 36cm)

MOVEMENT AND DISTANCE
It's a zigzag route to this shack. The murkier distance and zigzag path creates a sense of distance. Zigzags provide a sense of movement in the otherwise still, chilled scene.

FIRST SECTION
First, draw a few ridge lines. These represent the top of rises in the roadway. Starting from the top one (which will be the ridge farthest away), draw the portion of road that leads up to it from the ridge below. Make sure that you taper the section.

SECOND SECTION
Continue to add road sections as you work toward the front. Make sure that each section starts wider than the section above it. Don't worry if your road turns out wider in the foreground than your paper. This adds to the illusion of depth.

LAST SECTION
The more you offset the road sections, the more twisted the road becomes. The greater the differences in size between each section, the deeper the valley between them. Adjust the ends of the ridge lines to suit the landscape desired.

Using a Model for Perspective

This method of drawing objects in perspective is so simple that some people will consider it illegal. What you are going to do is make a simple model of your subject and hold it above your paper with one hand while tracing around it with the other. I will use a butterfly as an example because I've used those many times.

First, let me point out that I began this method not because I couldn't draw butterflies, but because I wanted to be able to freely play with the arrangement and position of them in my composition. By taping model butterflies to sticks, I could manipulate the arrangement until I found one I really liked. This method saved a lot of sketching and erasing time, but I still had a problem: How do I get my arrangement onto the paper?

The answer was simple: While holding the butterfly above the paper, I closed one eye and lightly traced around it as though it were on my paper. It wasn't perfectly drawn, but the butterfly's perspective would be accurate and in the position I wanted. I could refine the details later.

The hardest part of this process is keeping your head and hand steady.

The solution I found for this was to rest my hand on a stack of books and then make a conscious effort to move my eyes rather than my head while drawing.

I also found that if I had already sketched parts of my composition before doing this, the benefit was even greater because I could see the model in relationship to its setting.

Normally, I would frown upon the process of tracing because it implies the copying of someone else's work, but in this case, you're only tracing your own arrangement of a piece of work.

GIVE IT A TRY
Use heavy paper or cardstock to make your model. Butterflies or birds are easy because they're symmetrical and can be cut from folded paper.

Start by folding your paper in half and drawing half a butterfly or bird along the folded edge. Cut it out and add a small stick along the fold so you can manipulate it without getting your hands in the way. Curve the bird's wings to make them more realistic.

HOLDING STEADY
The trick is keeping a steady hand and head, and closing one eye. Here, the paper model of a building is being sketched.

Dynamics: Are There Any Signs of Life?

In most cases, it is not *what* you paint that creates energy; it's *where* and *how* you paint it. The best way to get and hold the viewer's attention is to make your picture exciting to look at. We call the energy that a picture exudes *dynamics*, much like a person exudes personality. Pictorial dynamics are not an arbitrary set of rules, but a reflection of how the human eye perceives the world. Using the principles of perception, experienced artists add energy and character to their work. You can, too.

A dynamic picture results from using a definite atmosphere, movement and strong contrasts. We covered atmosphere on page 45 and we'll tackle contrast on pages 53–54; for now, let's focus on movement.

MOVEMENT

The human eye is attracted to movement. Including some type of movement—even if it's just implied movement—will add excitement.

We perceive vertical elements—particularly lines and edges—to be stable or balanced. We perceive horizontal lines and edges as quiet and inactive. The edges of your paper or "frame" will be perceived as stable and calm. Anything in your picture placed at an angle to the frame will be perceived as unstable or in the process of moving. This adds energy to your composition.

But don't get carried away—character could also mean lively, gently flowing, dancing, ascending, swirling, floating, and so on. Movement can and should be portrayed according to what suits the statement you're trying to make about your subject.

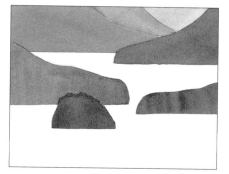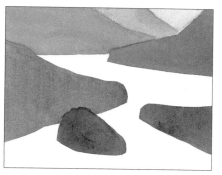

HORIZONTAL VERSUS DIAGONAL
The horizontal shorelines of the land masses on the left have a powerful calming effect. By angling the masses, you not only add implied energy but physical movement as well, by causing the viewer's eyes to follow a zigzag into the distance.

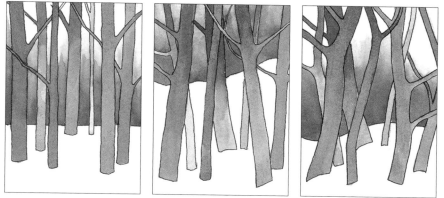

VERTICAL, LIGHTLY ANGLED, HEAVILY ANGLED
The same trees can have different character depending on how they are shaped and positioned. Note how the type and position of the horizon also affects the feel of the picture.

SUSPENSION THEORY
Objects that are in suspension will suggest motion in progress. This is an old cartoonist's trick, but it will work for you, too. Spray from waves, birds in flight and swirling leaves all add a fantastic sense of motion to a picture. Adding a shadow helps with the illusion.

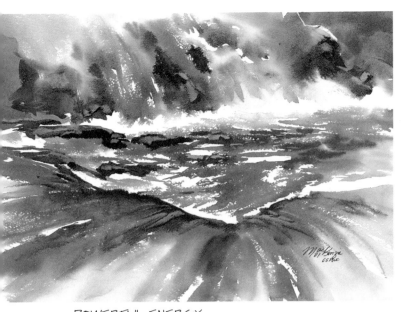

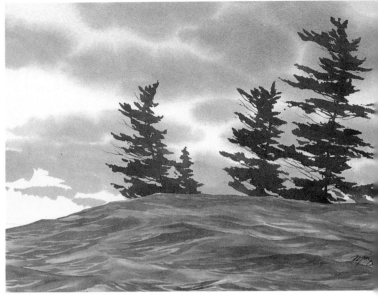

POWERFUL ENERGY
There are not many horizontal or vertical lines in this stream study, but the angles and diagonals give the impression of the water's rushing power.

STREAM STUDY
14" × 22" (36cm × 56cm)

SWELLS
The gentle curves in the waves, the top edge of the swell and the tree trunks produce a flowing sensation in this picture. By overlapping the trees with the wave, I am implying that the wave swell is rising in front of you. The drop in the top edge suggests that it is moving to the left.

SUNSET SWELLS, LAKE OF THE WOODS
11" × 14" (28cm × 36cm)

ANGLES AND LEAVES
Here the angled rails, combined with the bird and leaves in suspension, imply explosive action.

RAILS END SURPRISE
19" × 22"
(48cm × 56cm)

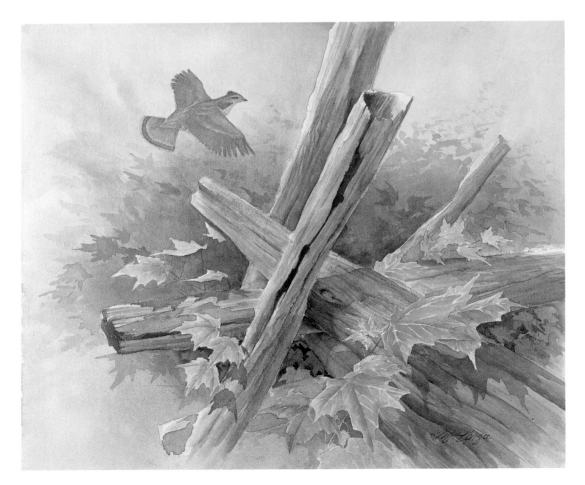

Contrast

Contrast is the primary way in which the brain distinguishes things. The stronger the contrast, the more it attracts attention—and vice versa, which is why low-contrast camouflage works.

Contrast in value is the most common form of contrast used by artists. In fact, the compositional and painting process is one of constantly arranging and modifying the values of various parts of the picture so that an adequate degree of contrast exists among them.

Sometimes values must be modified from how they appear in reality to what is needed in the picture to make a stronger composition. Just squint at your work; if certain areas blend into each other, you may need more contrast. If you make the shadows darker than they are in actuality and lose a little more detail in the bright highlights, you're simply making the scene more dynamic.

Placing colors of opposite temperatures next to each other is another form of visual contrast. The contrast becomes even more effective (and subtle) if the colors are mingled together by dropping or stroking one into the other.

In the visual world, contrasts are endless. For every condition there is an opposite—look for it and use it to establish contrast. The stronger the contrast(s), the more dynamics you add to your picture.

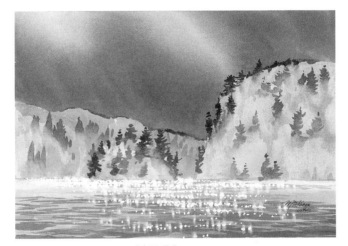

LAKE COUNTRY AUTUMN
11" × 14" (28cm × 36cm)

CONTRASTING TEMPERATURE, VALUE AND PURITY
To lighten and brighten a color to make it stand out, add some dark, dull color to the background. This dark, dull, cool sky makes the autumn hills flame.

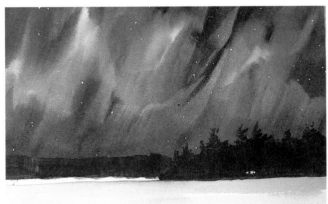

CONTRASTING VALUE AND ENERGY
The lake is a calm horizontal stretch of white. In contrast, the sky is mostly dark with light-valued diagonals for the northern lights and white pinpricks for stars.

SOLAR SYMPHONY
11" × 14" (28cm × 36cm)

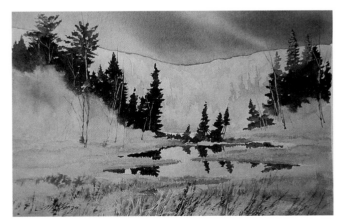

CONTRASTING TEMPERATURE AND VALUE
Here, the warm and cool colors contrast and mingle to produce a subtle glow. The dark pines stand out starkly against the light middle ground and foreground and lead the viewer's eye through the painting.

SNOW BEFORE ITS TIME
11" × 14" (28cm × 36cm)

THE MAGIC OF PROXIMITY

When colors are in close proximity, they tend to exaggerate each other's difference. For example, I can make one color appear much lighter by making its neighbor darker. I can make one appear more pure by dulling the mate, or cool one by warming the other. For whatever reason, the brain wants to create maximum contrast between everything it sees.

This can work to great effect in your painting. To lighten a sky, darken the trees, clouds, hills or whatever is in front of it. The bottom line is this: You can often achieve the changes needed in a color by doing just the opposite to its background.

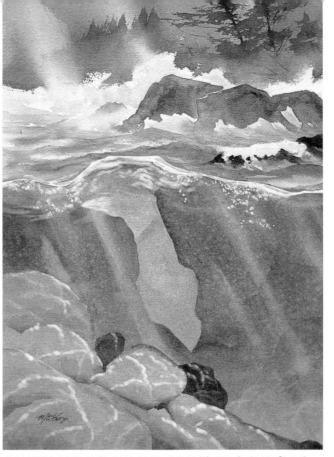

THE CALM BELOW
14" × 11"
(36cm × 28cm)

CONTRASTS BELOW AND ABOVE THE SURFACE
The contrast here is very intense. Where all the colors below the waves harmonize, the colors above contrast. More importantly, above the waves, there are varied details and sharper edges, as well as the violently crashing waves. Below, all is calm. The edges are rounder, the detail more vague and the movement seems limited to the spliced light dancing on the rocks in the foreground.

LIGHTENED
A color appears much lighter when its background is darkened.

BRIGHTENED
A color becomes much brighter when its background is dulled.

COOLED
A color is cooled and brightened when its background is warmed and dulled.

Priming the Imagination

If you have children you know that growth does not occur in a smooth, continual flow but in spurts, usually triggered by the purchase of new clothes. The creative process is no different.

Each time I reach a new level, there is great excitement and lots of things to try and places to explore. After awhile, things slow down and I start to lose interest in the way I am presenting my subjects. The creative drive is still there, but it's hard to find a worthy focus.

I am not always sure of how to get to the next level—or even what that level may be—so I explore variations on this one that will challenge me and keep me painting. I know for sure that I will not make the next leap unless I do this.

These are some of the approaches I have used to prime my imagination and get me moving again. Hopefully they will work for you, too. It's the way the game is played by beginner and professional.

Maybe if I bought some new clothes...

CHALLENGE YOURSELF

I like to set up a challenge for myself with each painting I do. In fact, I have always felt that my best pictures are the ones in which I have had to solve a problem. It doesn't always have to be nuclear physics—just something to challenge my inventiveness or imagination for that particular picture. Sometimes the problem arises from the subject I'm working on, and sometimes the challenge precedes the subject. Either way, I'm driven to better myself.

LISTEN TO MUSIC

Music speaks directly to the soul. Close your eyes and focus on the feelings and fleeting images generated by your music. Try to connect those feelings to any setting or scenario that your imagination might be generating as you travel. Have a sketch pad handy and, without breaking the mood, gently record the movements and rhythms of the music and any bits of images you are able to capture.

You may not get an idea for a picture with each piece of music, but you will at least experience the combined power of music and your imagination.

PRACTICE MEDITATION

Meditation is a natural extension of using music to stimulate the imagination. It just might turn out to be the most valuable addition to your painting process that you can make. This exercise does more than clear the mind. It can also be a time to receive intuitive information, a time for our inner self to speak when we have quieted our loud, conscious mind. But be ready: Your inner self speaks quickly and gently. It's easy to miss or dismiss it.

Don't expect meditation to work immediately. It takes practice, but the payoff is big. There are many meditation tapes and CDs out there that combine music and natural sounds that will teach you how to relax, visualize and "walk through" your inner landscapes. As French postimpressionist Paul Gauguin said, "I shut my eyes in order to see."

EXPERIMENT FROM PAPER TO IMAGE

Other than the printed page, printed information can take many unique forms such as maps, building plans, theater tickets, travel brochures, menus, invitations, sheet music—the list goes on and on. For each of these pieces of paper, there are endless image possibilities. Create a picture where you combine the piece of paper and the image that it brings to mind for you into one picture. You may have to do some research for the piece of paper and image(s) you use—and do lots of pre-sketching and planning to find a suitable composition—but then again, the challenge to create a unique image is what it's all about.

COMBINE PLAN AND PAINTING
Here are the plans for a canoe combined with the end result. The plans were drawn out on the paper first with a waterproof/lightproof pen. When dry, the picture was painted. When the picture was dry, I outlined the plans with packing tape and then removed color by gently scrubbing with a wet sponge and blotting with a paper towel. Using staining colors in the picture left the best after-image.

ROUNDING THE POINT
14" × 16" (36cm × 41cm)

COMPOSE WITH BINOCULARS
Using binoculars or field glasses to find a subject for painting is not much different from using the zoom feature of a good camera, except the enlargement is easier to see because you are using both eyes. Besides having the effect of eliminating peripheral detail like a simple viewfinder, binoculars can also blur unimportant details in the background and foreground. They also flatten a three-dimensional subject into two dimensions. This effect makes the subject look like overlapping paper cutouts, which can help you define layers or grounds in your composition.

TRY PAINTING FROM DUSK TO DAWN
This special time of day—after the sun has set, through the darkened night and to the break of dawn—holds promise for some truly powerful visual effects in your paintings. Without the usual overhead light of the daytime sun, you must illuminate your picture with such light sources as street lights, campfires, house lights, moonlight and candles. See examples of this on pages 130–133.

FOREST LIGHT
11" × 14" (28cm × 36cm)

TRY SOMETHING DIFFERENT

I believe that we paint the best pictures when we paint about what we have experienced and know best. Within that framework we should continually challenge ourselves to explore beyond the norm for different, fresh ways of presenting our subjects. You have a license to do anything you want. Use it. For example, when was the last time you tried…

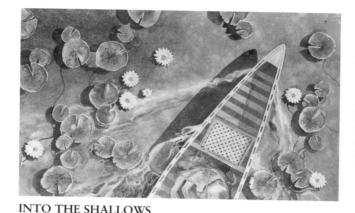

INTO THE SHALLOWS
22" × 24" (56cm × 61cm)

…an unusual viewpoint of your favorite subjects? From above, below, inside out, in silhouette, cross section, multiplied, close up, in fog, at night, etc.?

…changing the shape of the picture plane? This is done by masking border areas with packing tape or masking fluid so that the remaining picture space is not the usual rectangle.

FLOWERS OF THE FOREST
14" × 22" (36cm × 56cm)

…looking below the surface? Landscapes do not have to be on dry land. Anyone who has snorkeled or done scuba diving will attest to the beauty under the sea just waiting to be painted, especially with watercolors. See pages 88-89 for another example.

…distorting or exaggerating a subject—sometimes referred to as caricature? This invariably adds a lighthearted note to your work. They also offer you a chance to work like an illustrator with pen or brush and ink plus your watercolors.

In fact, when was the last time you mixed watercolors with another medium? Consider colored pencils, water-soluble crayons, wax crayons, waterproof markers, chalk or oil pastels, torn paper, fluid acrylics or gouache, all of which are compatible with traditional watercolors.

ST. POLYCARP, FRANCE
14" × 11" (36cm × 28cm)

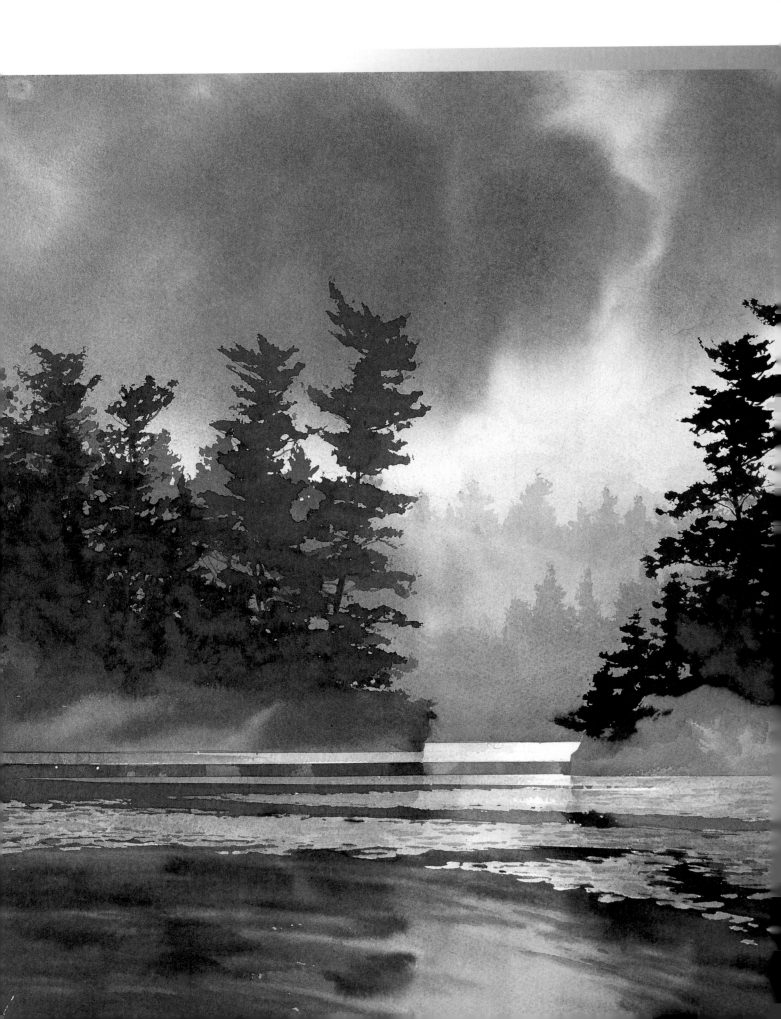

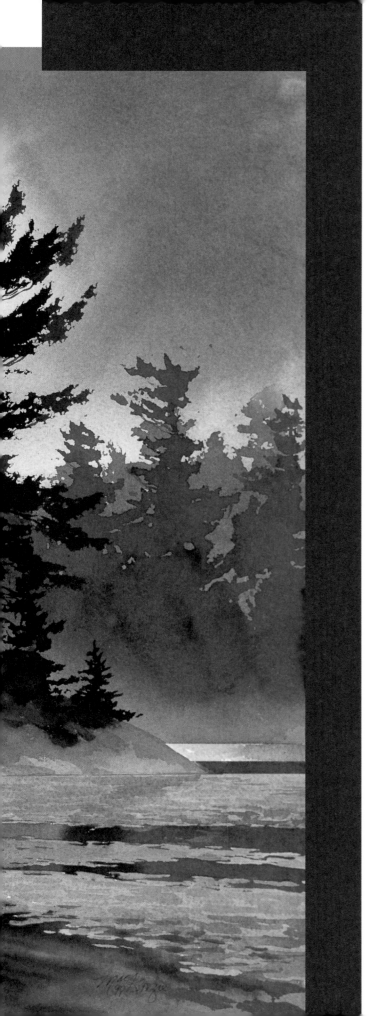

Landscape Elements 3
Water, Sky and Land

This chapter examines, one at a time, the choices or variations you can use within the three major aspects of a landscape painting—water, sky and land. The numerous exercises and examples will better enable you to handle any of these elements when it becomes a dominant player in your picture.

SENTRIES OF THE HEART
19" × 22" (48cm × 56cm)

Painting Water

Water supports all our endeavors, from the simple task of making paint flow, to sustaining life. It is the common denominator that all humanity shares.
—Anonymous

Water, next to air, is the most vital element for our survival. It is the earth ingredient that has most shaped the development and movement of civilization. It is fitting, therefore, that we somehow honor the magic, majesty and enduring energy of this element in our paintings.

Water can be one of the most complex characters you can add to a picture. It can also be the star that steals the show. Because it can play so many roles, from tranquil pond to pounding river, there are a wide variety of techniques involved that are specific to water. But beyond the techniques, there is other knowledge you must grasp. Recognizing and using the patterns that water follows or creates is one example. Perspective of a flat surface is another.

Exploring the exercises and demos that follow will have you awash with confidence to use water as a major element in your paintings.

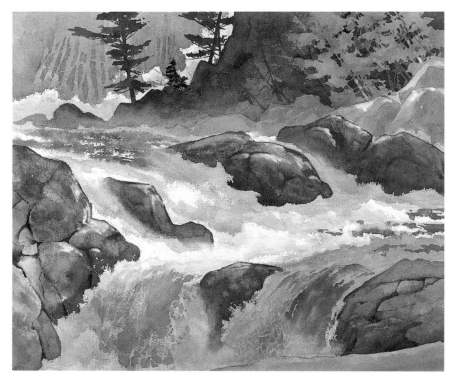

CYCLE OF LIFE
19" × 22" (28cm × 36cm)

MATERIALS USED FOR WATER EXERCISES

Surface
- 140-lb. (300gsm) cold-press paper, mostly 11" × 14" (28cm × 36cm)
- Rigid board for mounting paper

Paints
- Burnt Sienna
- Cobalt Blue
- Indian Yellow
- Permanent Rose
- Phthalo Blue
- Phthalo Green
- Raw Sienna
- Sap Green

Brushes
- ¾-inch (19mm) or 1-inch (25mm) synthetic flat
- 1½-inch (38mm) to 2-inch (51mm) synthetic flat
- ¾-inch (19mm) hog-hair bristle
- 1-inch (25mm) hog-hair bristle
- 1½-inch (38mm) to 2-inch (51cm) hog-hair bristle
- Assorted rounds (synthetic or synthetic/natural mix), nos. 8 to 14
- Small scrub brush (To make one, see page 16.)
- Flat synthetic stroke brush

Miscellaneous
- pencil
- eraser
- masking fluid
- rubber cement pickup
- water-filled spray bottle
- paper towels
- packing tape
- popsicle sticks or tongue depressors
- razor knife
- hair dryer
- piece of cellulose sponge
- stiff palette knife
- small piece of coarse sandpaper
- toothbrush
- thin sheet of acetate

Making Waves

Before you get swept away by the water exercises, practice making some basic wave marks that can be used on everything from calm waters to surging tides.

SHOWING PERSPECTIVE

For the sake of perspective, graduate your marks and the spaces in between from very large at the bottom of your paper to tiny near the top. There should be more undulation in the foreground and very little in the distance. Also, the color should lighten as you move into the distance. This aspect is very easy to do if you simply let your brush run out of paint as you work up the paper. Or, begin light in the distance and darken the mixture as you move forward. Unfortunately, one brushful of color won't paint your whole picture. You'll have to work from bottom to top along several paths.

TIP

This is a great time to let the rhythm of dance music get you in the flow. It's best to stand up so that you have the full movement of your arm. Besides, it's hard to dance sitting down.

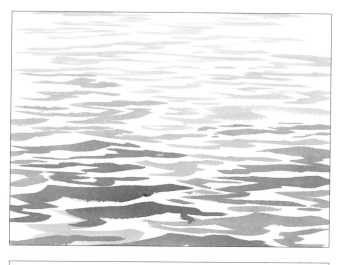

REAL WAVES
Vary the size, spacing and darkness of your marks, and try to avoid overlapping them. As the surface fills up, place the marks so that they interlock.

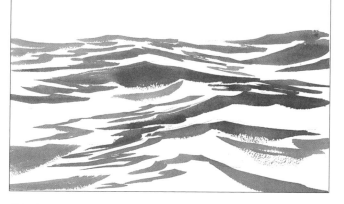

VARIATION
These marks can be used on larger swells as well as calm water. Notice the variety in the length and spacing of the waves.

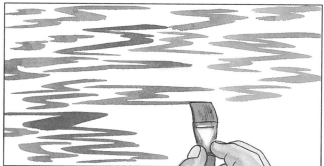

THE BASIC MOVE
Holding your flat brush as shown, move it from side to side, making a loose, broken zigzag pattern. Work your way up or down the page. Concentrate on varying the length of the individual strokes as well as the length of any continuous strokes.

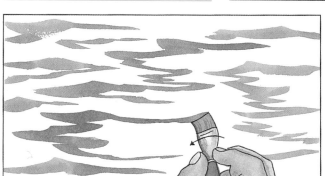

ADDING A TWIST
To make your marks look more like waves, add a small twist to your strokes. Do this by turning the brush ever so slightly upward at the rise of each wave, whenever you change direction, or at the end of each stroke. This will vary the width of each mark and create a more undulating appearance.

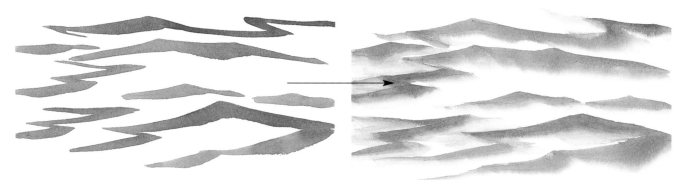

MODELING WAVE MARKS
To make the foreground waves look more three-dimensional, soften the bottom edges and ends of the closer major waves with a damp brush. In order for this to work you will have to fade out the marks while the paint is still wet. Therefore, paint only a couple of waves at a time before fading them out.

CALM WATERS TO LIGHT CHOP

BEGIN WITH A BACKGROUND
With any color you want for the water, paint a smooth graded wash from dark in the foreground to light at the horizon. Make two of these. Let one dry and use the other while it is still wet for the wet-in-wet process shown at right.

CREATE SWELLS
To indicate gentle, rolling swells add some darker horizontal streaks to the damp graded wash. You could also lift off light streaks with a damp brush. Let dry.

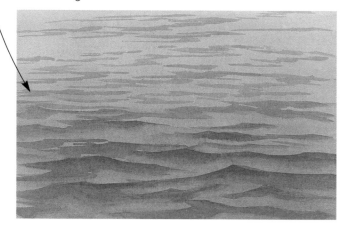

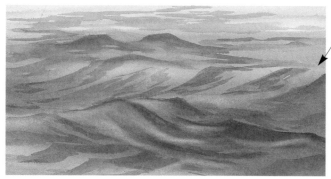

ADD WAVE MARKS
When the paper is dry you can start laying in wave marks in a loose zigzag pattern using a ¾-inch (19mm) or 1-inch (25mm) flat synthetic brush loaded with a more concentrated charge of the color. Start with the larger waves in the foreground and work upward to fewer, flatter, smaller waves in the distance (left). For the wave swells, paint the wave marks to suit the direction of the swells (above).

Wave Direction and Surface Patterns

The secret to painting realistic water is to have the waves and ripples appear to be following a consistent pattern. This pattern, which invariably involves perspective, is used as a rough guide for the placement of waves, ripples, sparkles and reflections. It is not the intent that you follow these lines exactly when putting in your waves. They need only follow the general direction and spacing.

SPACE BETWEEN LINES CREATES DISTANCE
This simplistic pattern illustrates how to create the illusion of distance by decreasing the distance between the rows of waves.

DIAGONAL LINES CREATE MOVEMENT
A pattern that runs at a diagonal to the frame adds energy to your work, but note that these lines are not parallel. They run to a common point outside the picture plane, the vanishing point (see page 48).

Offshore

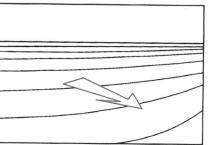

Onshore

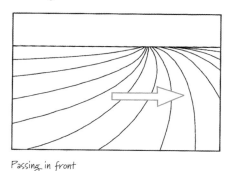

Passing in front

BENDING THE LINE EMPHASIZES WIND DIRECTION
Once you can draw wave guidelines diagonally, it's not much of a leap to draw the lines slightly curved because our arm naturally wants to move like a windshield wiper anyway. Turn your paper to take advantage of this wiper-like movement. This produces wave patterns evident when the wind blows diagonally away from you (offshore), toward you (onshore) or sometimes across in front of you.

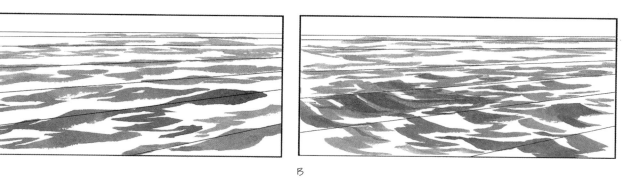

A

B

TWO WAYS TO PLACE THE WAVES
There are two ways of positioning your wave marks. One is to follow the angle of the guidelines (figure A). The other is to keep your marks more or less horizontal and follow the converging path of the lines (figure B). It's your choice. The wave marks are the zigzags you practiced earlier.

Interrupted Flow

Often the wave flow is interrupted by islands, rocks, points of land and such. The next time you're near a large body of water, pay attention to wave direction. You will be amazed at how much you will see when you are looking for something specific. A viewfinder will be of great value by giving you a firm horizontal/vertical reference base. It is always surprising to see what unexpected angles the lines for moving water can have.

TIP

Look at your sketch in a mirror. If it looks alright there, then chances are it is.

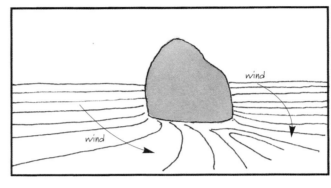

CALM WATERS
Wave patterns change when the water encounters land forms.

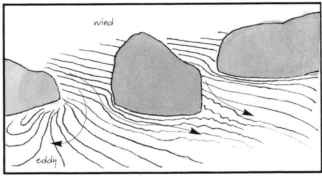

TURBULENT WATERS
By comparison, choppy water flowing around obstacles makes a slightly different pattern.

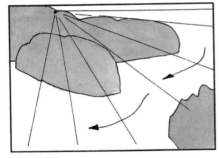

PRE-PAINTING SKETCH
Here, I set the horizon or eye-level line near the top of the picture plane for a high vantage point. The wave pattern lines rotate around a vanishing point located on this imaginary line. (See page 48.) Following these rough guides, I sketched slightly curving lines to indicate wind direction and to suit the contour of the land. I used these lines a reference when applying masking fluid for the sparkles. (See the next page for more on that procedure.)

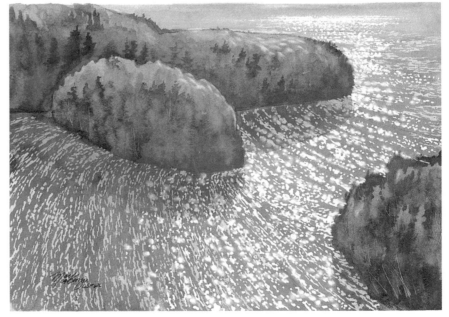

SPARKLES FOLLOW THE FLOW
Here the waves indicated by the sparkles curve around the point and into the bay.

DIAMOND DANCE
11" × 14" (28cm × 36cm)

Sparkling Waters

The best way to see sparkles dancing on water is to squint as you look. Note the pattern they make because you are going to use masking fluid to re-create that pattern.

COLOR NOTE

When mixing together the three colors of a triad, you will get various dulled colors. What kind depends on which color is most dominant in the mix. If it is blue, then the result will be a dulled blue. If it were red, then a dulled red. If red and blue are equally dominant, then you will get a dulled mauve.

1. Sketch and Apply Masking

Sketch your plan and indicate the crests of a few major foreground/middle-ground waves. Apply dots of masking fluid for the sparkles using the butt end of a small paint brush. Cluster your dots in varying sizes along the crests of the waves, with a few scattered in between. As you work into the distance, make your dots smaller and your rows closer together. You may wish to leave gaps for calm areas among the sparkles.

This can be a mind-numbing process, but stick with it and try not to be stingy with your dots. Every one represents a sparkle. Without them, the water won't shine.

2. Choose Colors

The palette used here is the triad Cobalt Blue, Raw Sienna and Permanent Rose because I wanted fairly transparent, non-staining colors. More important than a preconceived color for water is the use of correct value, intensity and temperature to suit the atmosphere you want. For a sunny day, use mostly pure forms of your triad colors or mixtures of only two colors at a time. For a warm, hazy atmosphere—which is the case here—mix all three colors to produce a dulled dark and warm color (here, dulled mauve).

3. Paint the Water and Sky

With your dulled mauve, paint a graded wash from dark in the foreground to light in the distance. Paint past where the far shore would be. Paint a sky that would suggest a soft, warm light by adding more yellow and water to your mix. Let dry.

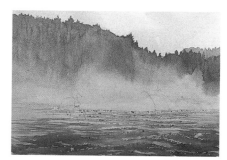

4. Add Land and Detail the Waves

Paint the top of the distant land with a darker mixture of your triad colors. While still wet, fade it out downward into the mist. Model the backsides of the larger waves with a more concentrated color.

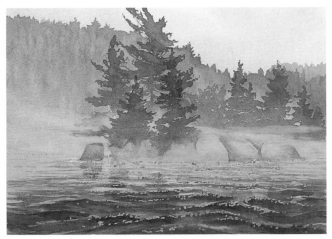

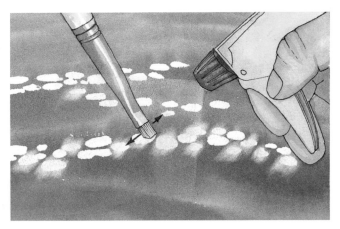

5. Add Middle-Ground Detail

Continue with the same dulled triad mixture. To continue the illusion of a hazy atmosphere, paint the hills and middle-ground trees as single masses. For depth, use darker and darker colors as you come forward. Keep the rocks light for contrast.

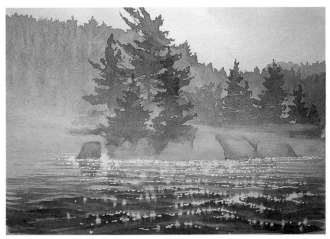

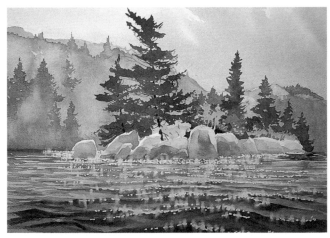

SAME TRIAD, CLEARER DAY
This painting was done with the same triad but here the more pure colors were used or only mixed two at a time. There is more value contrast and detail shown because it's a clearer day.

MORNING DANCE TWO
11" × 14" (28cm × 36cm)

6. Create Sparkle

When the paint is dry, remove the masking fluid from the dots with an eraser or rubber cement pickup.

To achieve the illusion of light on the water's surface, spray the whole area with lots of water—literally a small lake—and then soften *some* of the dots by scrubbing with a small hog-hair scrub brush. Be consistent in the direction of your scrubbing. Unless you have painted with a lot of heavy opaque colors, nothing will move under this extreme wetting unless you touch it with your scrub brush.

When you have finished scrubbing as many dots as you want, pour off the water and blot—don't rub!—the surface with a paper towel.

MORNING DANCE ONE
11" × 14" (28cm × 36cm)

Masking Ripple Marks

Ripples are the marks made by light breezes on a calm surface. You could save the entire ripple area with masking fluid, but I have found that if I use packing tape for the core of these areas and masking fluid along the edges, I can save a lot of time and masking fluid. Besides, the tape produces far more precise lines and edges that are needed on distant ripple areas.

Warning: Test your paper first. Packing tape will not work on some papers. Arches is one of the brands recommended for this process.

1. "X" Marks the Spot

Sketch the areas or shapes that you want to save as ripple areas. Use a ruler to get the distant areas straight. For this exercise we'll keep it simple.

2. Apply Packing Tape

Apply overlapping pieces of packing tape over the designated area. At this point, press down lightly. Don't worry about a few wrinkles. Carefully cut the packing tape with a razor knife according to your guidelines and remove the unwanted pieces. Now, firmly press the taped areas. You should be able to see the texture of the paper in the tape.

3. Apply Masking Fluid

Apply masking fluid along the edges of the taped areas in the foreground and some in the middle ground. It's easy to apply with a popsicle stick or tongue depressor that has been carved with a chisel edge. You are trying to create a gentle gradation between the ripple area and the calm area. Make sure that the hard edge of the tape in the foreground is completely obscured with masking fluid. Let dry.

TIP

If you have not worked with packing tape before, you can save a lot of headache by reading pages 28–29.

3. Paint the Sky, Hills and Reflections

Paint the sky and its reflection a pale Raw Sienna. Let dry.

Paint the land and hills simultaneously. Wet these areas and apply patches of Raw Sienna, Burnt Sienna and Indian Yellow to represent distant autumn trees. Paint the reflected patches with the same colors. While still wet, paint a blue-gray (Cobalt Blue + Burnt Sienna) around the warm patches.

On the land, define the hilltop. In the water use vertical strokes to suggest reflection. While the painting is still damp, add darker evergreens using Cobalt Blue and Sap Green.

4. Complete the Painting

Remove the packing tape first. Lift the corner with a knife blade. Warming it with a hair dryer will ease its release. Remaining masking fluid can then be removed with a rubber cement pickup.

Paint the ripples a pale Cobalt Blue because they indicate the sky above you, not the sky at the horizon. In the foreground, darken the ripple marks in the lighter ripple area and reflected sky area. This eases the transition between ripples and calm water.

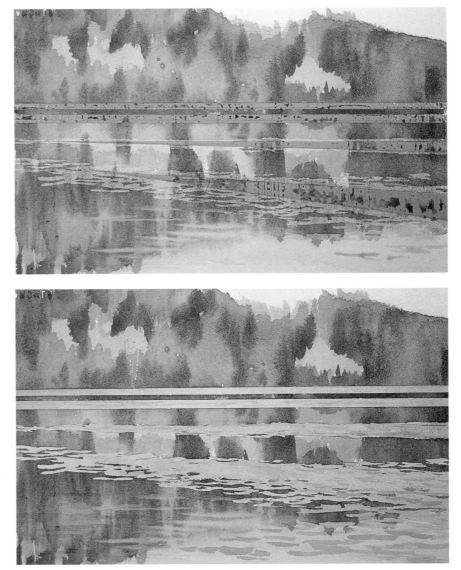

RIPPLE STUDY
11" × 19" (28cm × 48cm)

68

The Laws of Reflection

When you are working with water, there are four hard and fast characteristics of reflections that you must use in order for the water to look authentic.

CHARACTERISTIC #1
On a body of water, a reflection is always directly below the thing being reflected.

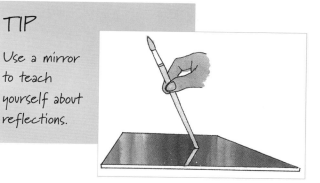

TIP

Use a mirror to teach yourself about reflections.

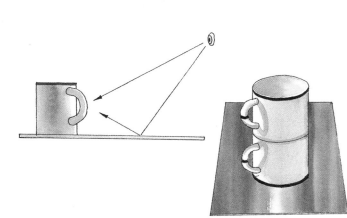

CHARACTERISTIC #2
The reflection is rarely the exact same as the object being reflected. The reason is that the reflection is a different view of the object—actually, a view from below. This is something to keep in mind particularly for foreground and middle-ground reflections.

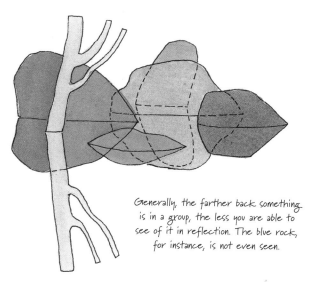

Generally, the farther back something is in a group, the less you are able to see of it in reflection. The blue rock, for instance, is not even seen.

Note how the reflection is actually behind the tree when it has fallen away from us.

Reflections become shorter when the object tilts away from us.

CHARACTERISTIC #3
The length of a reflection (in calm water) depends on whether the object or plane is tilted toward you or away from you. The reflection gets longer and wider when the object or plane is tilted toward you, and shorter and narrower when tilted away.

Reflections become longer when the object tilts toward us.

CHARACTERISTIC #4
Reflections become elongated when the surface of the water develops ripples. Each wave acts like a tiny moving mirror that is able to reflect objects over a greater area of the water. The result is a reflection that is much longer than the object.

To create light distant reflections, wait until the painting is dry, then lift off horizontal marks by rubbing with a damp sponge. Use pieces of paper as stencils to preserve straight edges. When dry, you may need to touch up some of the ripple marks.

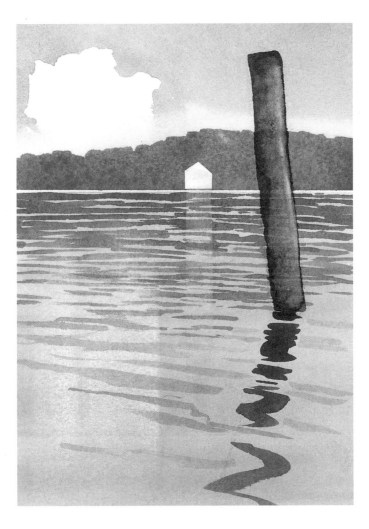

Calm Reflections

There are many degrees of "sharpness" in calm reflections. In this back-lit subject, the reflections are somewhat less than mirror-perfect.

1. Prepare the Background

Mask out the canoe with packing tape or masking fluid. For the forest background, paint a graded wash that transitions from warm green (Sap Green + Indian Yellow) to cool green (Sap Green + Phthalo Green). Let dry.

2. Add Trees

Sponge or brush on dark foliage with greens ranging from Sap Green near the light to Phthalo Green at the edges. Leave some white areas for the shoreline rocks. When dry, paint the rocks, dark trunks and limbs between the clumps of foliage with a dark blue-gray (Cobalt Blue + Burnt Sienna). Use a palette knife to add texture to the trunk and to define the tops of the rocks.

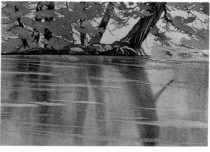

3. Paint the Reflections

This is one long, continuous step, so prepare pools of paint before you start.

Gradate a wash of Cobalt Blue from dark in the foreground to light in the background. While wet, brush on bold vertical strokes of greens, starting with yellow-green and then using dark warm and cool greens. Leave some areas of blue (reflected sky) showing.

While still wet, paint the trunks with a dark gray-brown (Cobalt + Burnt Sienna). When this dries to the damp stage, lift off a few light ripple lines with the edge of a damp flat synthetic brush. Follow with a few strokes of blue with the same brush. Let dry.

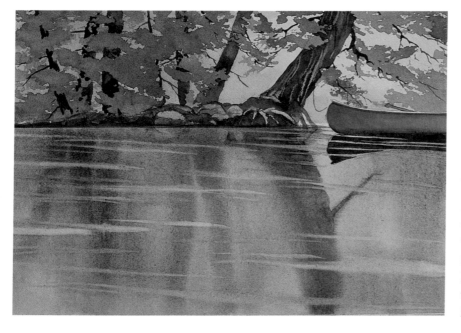

4. Finally, the Canoe

Remove the masking and paint the canoe in a red that is darkened with a drop of green. Paint its reflection with the same color, leaving gaps for ripples. Sharpen the edge of the tree reflection near its base.

Techniques for Dynamic Water

There are many ways to paint moving water, from wave swells to crashing rapids. The next few pages show the main techniques.

WET-IN-WET
The two examples below use wet-in-wet methods of depicting moving water.

TIP

A zigzag on the water can act as a guide for placing wave marks. Major wave stokes flow away from this mark, leaving a light ridge for the eye to follow.

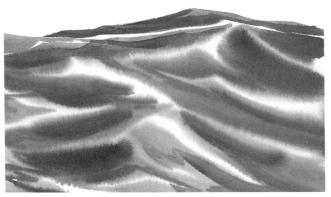

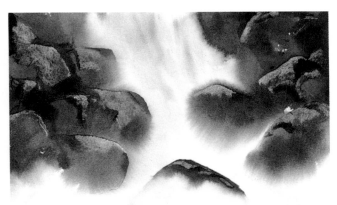

WAVE SWELLS

For this wave exercise, wet the paper only as far as the top of the sea, which you will notice is not perfectly horizontal. When you start painting the wave, first define the hard top edge of the water by painting just beyond this wetted area. This will give it a hard edge against the sky.

For the wave marks, use a 2-inch (51mm) synthetic brush well-loaded with concentrated color (e.g. Phthalo Blue). It is important that you paint the marks quickly with bold strokes, leaving space between them. Each mark will diffuse but not quite meet its neighbor. The result is a light pattern of lines that defines the movement and undulations of the water. Strokes can be varied by holding your brush vertically and turning it while increasing the pressure up and down as you make the stroke. While the blue waves are still wet, add a few smaller strokes of darker green on top for emphasis.

WATERFALLS AND RAPIDS

Completely wet the paper and define the water flow with a few pale blue strokes. When this dries to damp, paint the rocks with any dark, concentrated brown-blue mixture (e.g. Cobalt Blue + Burnt Sienna) using a 2-inch (51mm) flat synthetic brush. Leave a path for the water. When that dries to damp, model some rocks by scraping back with a palette knife. After it has dried completely, go back and clearly define the top edges of rocks in the stream with more dark color. Fade out into the rocks. Then paint the top of the foreground rock, soften along its bottom edge and scrape the top.

DRYBRUSHING

The only difference between drybrushing and traditional wet-on-dry painting is the angle at which you hold your brush. Both brushes are well-loaded with paint, but with wet-on-dry you hold the brush upright and use the tip to apply paint in a solid stroke. For drybrushing, you apply paint in a broken pattern with the side of the brush. For this technique, it helps if you use a brush with long, coarse bristles, such as a hog-hair or badger.

The trick (There is always a trick.): Stand up and move your entire arm and body. This ensures that the brush will remain at the necessary low angle throughout the stroke.

FLOWING WAVES
For drybrushed waves, use long, sweeping strokes. Notice how the change of direction in the strokes adds variety to the movement of the waves.

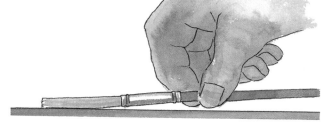

A LOW-ANGLED BRUSH
To paint with the side of your brush, you must hold it low to the paper. A 2-inch (51cm) hog-hair brush with long bristles is excellent for this process. Ironically, this method of drybrushing is not done with a dry brush. It is done with a well-loaded brush that drops a lot of paint from its side.

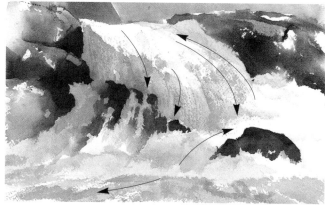

RAPIDS
Drybrushing adds texture and movement to a stream. While the first marks are still damp, apply a second different-colored layer on top for variety. You may find it more effective to pull some of your strokes upstream. Add the rocks after the water dries.

CRASHING WAVES
First, paint the wave area a pale blue and let dry. Using a midvalue blue, drybrush pattern and movement on the waves. When this is dry, drybrush a dark brown-gray (Cobalt Blue + Burnt Sienna) for the rocks. Paint your first strokes downward to make a lacy spray, and then carry the paint upward to build the rock shape. When this dries to damp (starts to lose its shine), scrape some lighter rock faces with a palette knife.

PARTIAL WASHES

Yes, Virginia, there is such a thing as a partial wash. It's basically dry-brushing with clean water, except you add color after you make the stroke. Partial washes are fantastic for creating foam, sparkle, water movement and ice.

One of the beautiful features of a hog-hair (bristle) brush is the loose pattern of water that it lays down when dragged on its side. This pattern, or partial wash, can then be used to carry paint that is dropped into it into a loose broken pattern that can be used in many places in your landscape. Because the brush is dragged, it makes a linear pattern that defines movement in the water as well.

The longer the bristles on your hog-hair brush, the better this process works. The colors dropped in can vary, but all should be concentrated for maximum contrast and prepared *before* you put down your partial wash.

LAYING DOWN THE WATER

To apply a partial wash, drag your brush—well-loaded with water—across your paper. Try not to lift your brush as you go, otherwise water will come off the leading edge and give you a solid wet mark. Repeat the stroke until you are satisfied with the coverage in the desired area. Standing up makes it a lot easier to make a consistent mark across the paper.

Getting this water pattern down is the most important part of this process. If you get too much water on the paper, you won't have any sparkles when you add the paint. On the other hand, if you don't put down enough lacy pattern, you won't get the colors to flow. Practice makes perfect. Use the backs of old paintings if they are not too buckled.

ADDING COLOR

Let the water do the painting. Your job is to deliver lots of paint to the partial wash as soon as it's down, and let the water do the rest. Use a large, well-loaded flat synthetic brush. Hold it vertically and just touch it to the paper lightly. As soon as it finds water, the pigment will burst out of the brush to create wonderful patterns. Hold the brush in the direction of the wash. Keep reloading color and dropping it as long as you want.

Finally, if necessary, soften the edges of the wash with a damp hog-hair brush so that it blends into its surroundings.

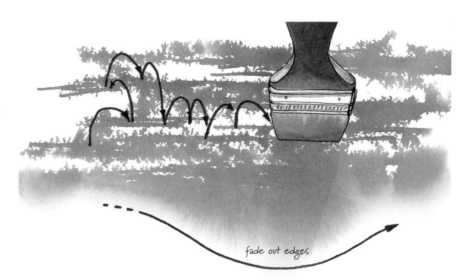

fade out edges

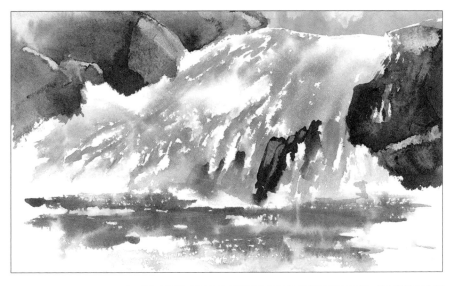

WATERFALLS

In this example the partial wash defined the direction of flow for the waterfalls and the pool at the bottom. Once color was added to the partial wash, the edges were softened with a damp hog-hair brush. The rocks were painted when the washes were dry.

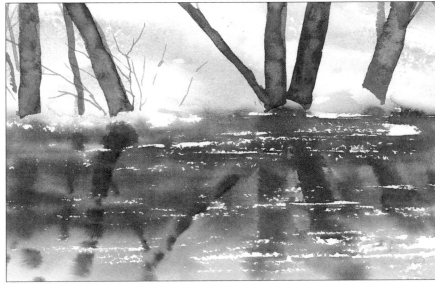

CALM REFLECTIONS

This horizontal example started with a fairly wet partial wash resulting in only a few small dry areas. Notice how you can use more than one color for your water if you have them mixed before you start the partial wash. The edges of the wash area were softened with a damp hog-hair brush. This produced the soft edge of the snow bank at the top. The tree reflections were painted last while the surface was still damp. Care was taken not to paint over dry spots.

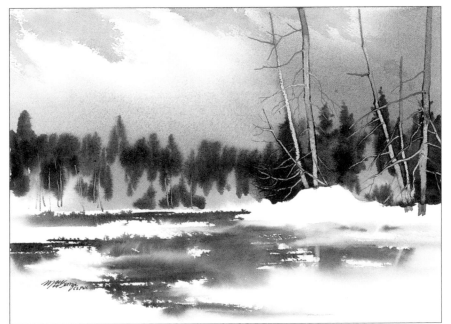

DEPICTING ICE

Here the partial wash captures the transition between ice and open water.

Sea Spray

Active water crashing into land often produces spray. This evidence of energy in nature can add a note of excitement and energy to your pictures.

Here are two ways to create that dramatic effect: one with rough sandpaper and one with masking fluid.

SANDING FOR FINE SPRAY
For this technique you need a dark background against which to contrast the spray. In this case, we will use the sky and dark rocks.

1. Paint the First Wash and Lift the Spray Area

Pant a midvalue-blue wash over your entire paper. While this is still wet, use a damp brush to lift an irregular white area where you want the main body of spray to be. Let dry.

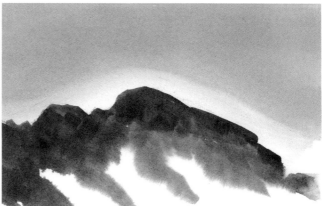

2. Develop the Rocks Around the Spray

Wet only the bottom part of the spray area. When this dries to damp, paint the rocks so that their tops are hard-edged on the dry paper and their bottoms are blurry in the damp area. Use a dark color (Cobalt Blue + Burnt Sienna) to define light fingers of spray in front of the rocks. While the rocks are still damp, scrape with a palette knife for highlights and texture. Let dry.

3. Sand Out the Foam

Use a small piece of coarse sandpaper, a little nerve and a lot of pressure with your thumb to sand from the white foam area out into the darker background.

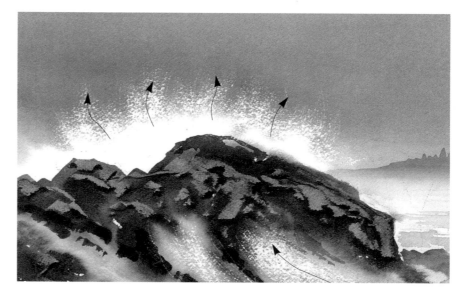

MASKING FOR SPRAY

You can create a fairly intricate scene with crashing water by masking the foaming water part with a sponge and spattering masking fluid with a toothbrush for the finer spray.

Nifty handle (see page 16)

Palette knife blade

THE KEY TO SPATTERING SUCCESS

The trick to spattering paint or masking fluid with a toothbrush is to push the bristles across the blade of a palette knife that is held horizontally. This prevents big drops from falling off the back of the blade.

1. Sponge On the Heavy Spray

To produce the irregular lacy mark for foaming water and heavy spray, use a torn piece of cellulose sponge (see page 31) to apply the masking fluid. Pour the masking fluid onto a plastic lid to make it easier to get at with your sponge. Moisten your sponge and touch just the face of it to the masking fluid. Gently "print" a lacy pattern on the paper for the spray. This is the end of the road for the sponge, so work quickly to build your pattern of spray.

2. Spatter On the Fine Spray

Touch just the ends of the bristles of your toothbrush into the masking fluid in your lid. Use your thumb or palette knife to spatter masking fluid around the edges of your sponged area. Wash your toothbrush immediately so the masking fluid doesn't dry in the bristles.

3. Add the Water and Background

Paint the water and rocks whatever colors you wish, but try to establish a dark contrast for the spray. Let dry.

4. Remove Masking and Finish

Remove the masking fluid with a rubber cement pickup. Use a small scrub brush and water to soften the bottom edges of the masked areas so they blend into the rest of the water. Apply a few shadows to the foam with pale blue. See page 85 for another example of this way of painting spray.

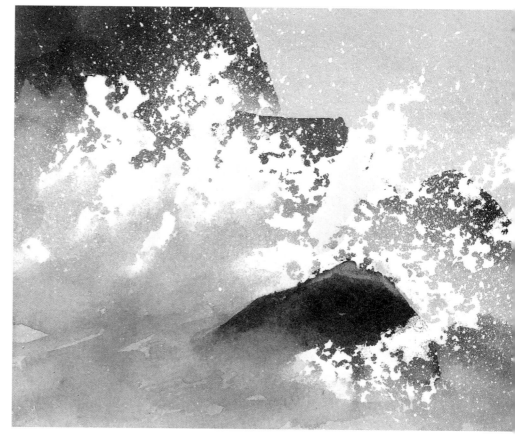

Rapids

Painting rapids or falls is a good example of how we often get better results by painting what the picture *needs* instead of what we actually *see*. Most rapids and waterfalls have a lot of midvalue- and dark-colored water. Add to this the darkness of rocks, sand or silt that it passes through, and you may find your pristine water looking more like a sewage outflow.

To combat this, I use a lot more white and light colors in the water and a wider range of values and temperatures in the environment. We all know that the rougher the water, the foamier it is, so by painting water that is lighter than normal, you'll also be adding some rip-snorting action to your picture.

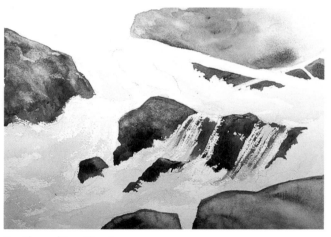

COLOR NOTE

In this exercise, I used Cobalt Blue for blue, Sap Green for green, Permanent Rose for red, Burnt Sienna for brown, and Raw Sienna for yellow because all of these are nonstaining and fairly transparent.

1. Plan the Flow

Make a thumbnail sketch that indicates an interesting flow through the picture space.

2. First the Water

After lightly sketching your plan onto your paper, you are ready to paint the flow in your stream. Use the side of a 2-inch (51mm) flat hog-hair brush loaded with a pale blue-green-brown mixture. Starting at the top of the rapids, quickly drag the brush (drybrushing) downstream, following the undulations of the flow. Save lots of white paper. This does not take long and immediately sets up the dynamics for your picture. Fade out some of the edges of these lacy marks with a damp brush. Let dry.

3. Now the Rocks

Paint the surrounding land and rocks to define the water's edge and movement. Start with the area behind the logs with colors that will allow for negative painting of trees and rocks later. Next, paint the rocks with a mixture of brown, red and blue. Paint one rock at a time so that you can focus on how it meets the water and its textures. (Create texture by dropping water into the damp paint.)

Keep the tops of the rocks hard-edged. At the water's edge, they can either be softened with a damp brush or given an irregular hard edge with the side of a bristle brush. Load your bristle brush with rock color and drybrush the water flowing over the central rock. Soften the marks with a few strokes of a damp brush.

4. Background and Turbulence

Negative paint to suggest trees and foliage in the background. Draw tree trunks and branches with a pencil first if you wish.

Define turbulence in the waves and foam with the side of a small hog-hair brush loaded with pale blue-green gray (blue with a touch of brown and green). Fade the top of each mark upward with a damp brush. In the foreground turbulence, add a few holes in the froth.

Paint what can be seen of the distant foliage and sky. Paint the logs a pale blue-yellow mix. Darken under the logs and where they are wet.

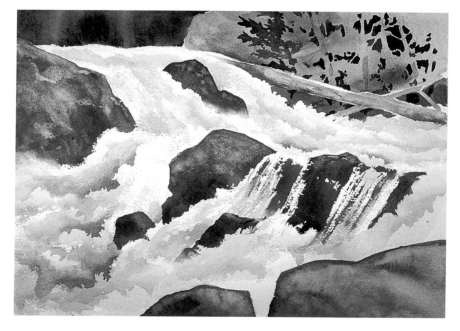

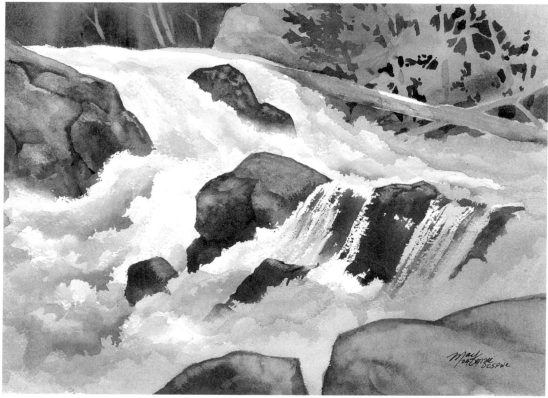

5. Details and Shadows

When completely dry, add detail (cracks, indentations, etc.) to the rocks. The final touch when it is completely dry is to add shadow. Mix a thin blue-gray and quickly glaze it across the lower part of the rapids using your 2-inch (51mm) hog-hair brush. This gives the impression of unseen hills or trees that intimately surround the scene. It also forces the eye to focus on whichever part of the rapids you want the viewer to see, which in this demo happens to be the upper part.

Big Water

If you haven't already done so, I strongly recommend that you practice making wet-in-wet waves with your 2-inch (51mm) flat synthetic brush before starting this painting (see page 72).

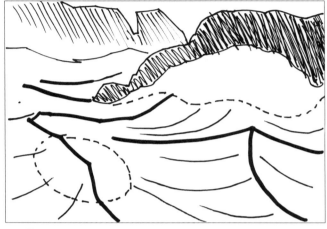

1. Plan Your Layout

Draw lines where you want the tops of the major swells. These lines will serve as a starting point for the direction of minor ridges and valleys. You might also want to indicate where you want to preserve white areas for foam and spray.

2. Lay In Wet-in-Wet Wave Marks

Wet the entire paper. When it dries to damp, load a large flat synthetic brush with a midvalue blue-green (Phthalo Blue with a touch of Sap Green). Boldly lay in the dominant strokes that flow away from or between your major ridges. Focus on varying the length of the strokes and leaving space between each. Reload your brush and continue with smaller, lighter strokes right into the background. The spaces left between strokes and along the tops of ridges provide soft white lines that define the movement of the waves. Make sure to leave white for areas of crashing waves. Let dry.

3. Paint Where the Land Meets the Water

Across the front of the rocks you will combine flowing colors and drybrushing. Wet the left half of the spray area, being careful not to go beyond the rock shape at the top and left end (refer to outline). Load a flat bristle brush with a dark blue-brown mixture. When the wet area dries to damp, paint the top of the rocks just outside the wet area on the left side. Bleed this color down into the wet area, giving the impression of soft spray. Start at the left, and continue along the rock face until you reach the dry area.

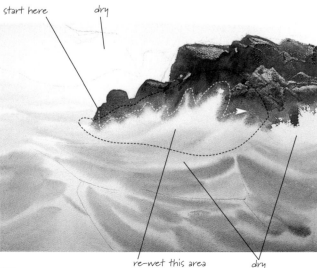

start here dry

re-wet this area dry

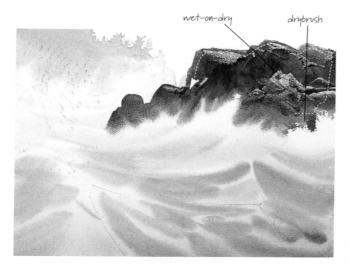
wet-on-dry drybrush

4. Develop the Rocks and Background

When you reach the dry area on the right, lower your brush and paint an irregular lacy edge with the side of the bristles (drybrushing). Reload if necessary. Return your brush to a vertical position and continue to carry this dark color upward and then back toward the left. Create a hard edge for the top of the rocks. While this is still damp, scrape back some rock faces with your palette knife.

Paint the background land a paler blue-gray (blue plus brown). Make the bottom of this mark irregular. As soon as it is painted, use a damp brush to fade out the bottom edge into the waves or fog.

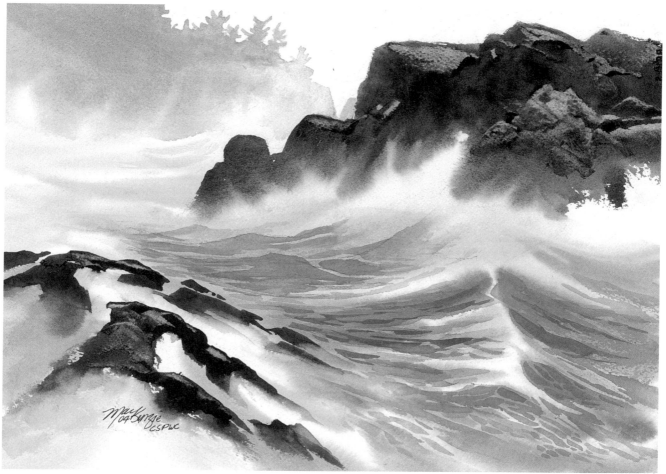

5. Finish With Foreground Detail

Paint the protruding foreground rock wet-on-dry, as if it were fragmented. While it is wet, soften the bottom edges of the fragments with a damp brush. When this dries to damp, scrape out some rock highlights with a palette knife.

To finish, add some darker wet-on-dry wave marks and holes in the froth that follow the swells.

Patterns in the Foam

Active water often produces foam and bubbles that create interesting patterns of movement on its surface. These can be painted one bubble hole at a time; however, the objective here is not to create holes in the ocean but the illusion of lacy ribbons of foam on top.

Practice on sketch paper or the back of an old painting. Use a no. 10 or larger round synthetic brush and a pool of any dark color you want.

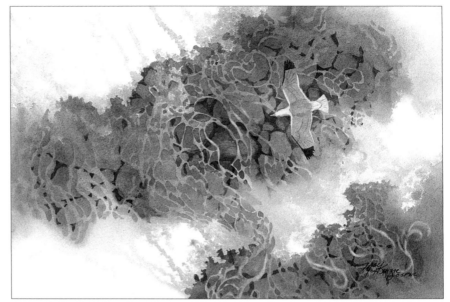

ROCKY BOTTOM
The illusion of floating foam is enhanced when some of the rocks on the bottom are painted in the holes of the foam. Paint some large holes in your foam so that you can do this sort of thing.

SURF RIDER
11" × 14" (28cm × 36cm)

1. Start the Shapes

Paint one large, smooth, irregular shape. Paint a second that fits perfectly against it without touching it. Paint a third of a different size that fits into the first two.

2. Continue Adding Shapes

Add shapes, consciously making them different in size and position and an irregular distance apart until you have created a large cluster of bubble holes. Try to keep the value of the holes about the same.

3. Define the Foam

Make the white lines stand out by painting around the cluster and fading out into the background.

In a finished painting, the background would probably have some color already.

Whitecaps

In this exercise you will use a paper towel rope to lift off color in the shape of whitecaps by pressing it firmly onto the painted surface with both thumbs.

Grab the corner of a paper towel and twist it into a tight rope.

Blot with your paper rope.

1. Paint Background Wash and Blot Whitecaps

Paint a wash that gradates from blue in the distance to blue-green up close. Use nonstaining colors, such as Cobalt Blue or Ultramarine Blue and Sap Green or Raw Sienna. Leave some of the foreground white if you wish to have foam around rocks on the beach.

Quickly twist a paper towel into a tight rope (see diagrams). While the paint is still damp, blot white-caps with the rope, starting in the foreground and working toward the distance. Make your marks larger (by loosening the rope) and farther apart up close, and smaller and closer together in the distance.

2. Develop With Darks and Shadows

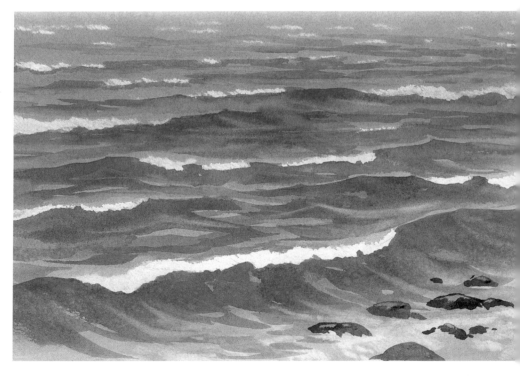

When the painting has dried, lay in darks along the tops of the major waves and under the white-caps. Notice that since a wave usually drops in height as the whitecap forms, it makes sense to paint the part that isn't breaking higher. Fade this dark color down the wave and into the valleys.

Lay in some shadow on the whitecaps as well. To indicate movement between the waves, use drybrushing or a flat synthetic stroke brush loaded with a darker color to make smaller wave patterns. Add water texture (drybrushing) around the beach area and paint any rocks desired.

Capping and Breaking Waves

WHITECAPS

Rows of whitecaps can be masked out using a sponge and masking fluid (next page), but in these exercises you will paint around them using a hog-hair brush. Cobalt Blue and Sap Green were used because of their nonstaining transparency.

1. Save the White Caps

Start by painting around the bottom of a foreground white cap using a well-loaded hog-hair brush. Carry this color to the left and right to finish the top edge of the wave. Since waves decrease in height when they break, make the rest of the wave slightly higher. Carry color downward until you get to the foam of spent waves in front. Define the waves farther and farther back by repeating this process but stopping at the top of the wave in front. Don't forget to decrease the size and spacing of distant waves.

2. Model the Waves

Darken underneath the whitecap with more concentrated wave color. Fade downward into the trough. While this is damp, water can be painted on the foreground wave slopes in lines to help suggest the contour of the wave and valleys. After all is dry, add shadow to the foam.

BREAKING WAVES

Big waves often roll or break after they have capped.

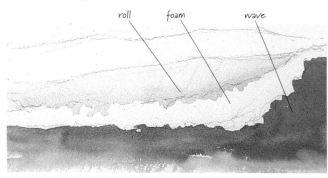

1. Save Room for the Roll

Make a sketch showing room above the foam for a roll in the wave. Paint the wave a darker blue-green at the top and underneath the foam, fading downward into the trough. Paint the roll area pale blue.

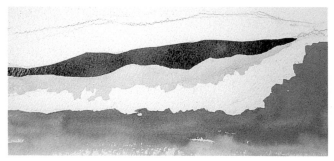

2. Paint the Roll

Paint the top area of the roll a solid dark blue-gray. Go immediately to step 3 on the following page.

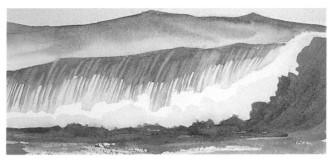

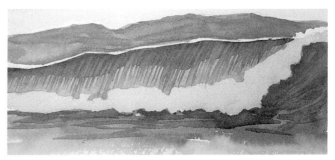

3. Paint the Lines on the Roll

Make curved lines with a small, damp, flat synthetic brush. Start the stroke in the dark area and draw it down into the light part. Stop the line where you want the top of the foam to start. Clean your brush as needed. Repeat this over and over along the length of the roll.

Drybrush a pale blue-gray texture onto the foam area. Darken it around the bottom edges.

Option One

If you want your waves to have front or overhead lighting, then continue by putting in background waves that are dark near the top and fade into the valley so that it contrasts the breaking wave.

Option Two

It is not unusual when the sun is low in the sky to see light coming through tall waves. I call this split-second treat the "jewel" of the wave. If you wish to include this illusion of transparency, you must do three things:

1. Paint the wave in the background dark but leave a small space between it and the top of the roll. This will look like sun bouncing off the edge.
2. Paint a pale green over the roll area. Darken this toward the ends.
3. Add more blue shadow to the foam section since it will be out of the sun.

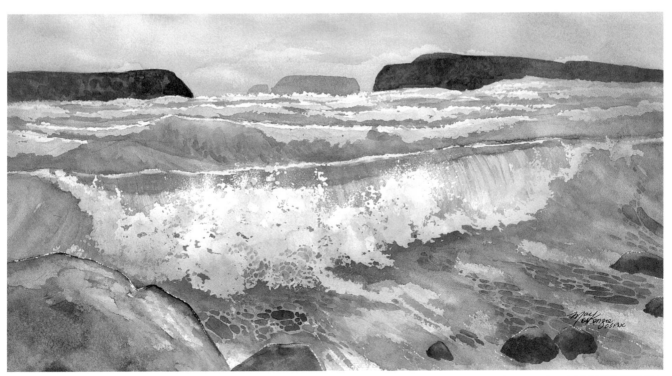

MASKING FLUID TECHNIQUE
Here is an example of waves capping and breaking where the foam was saved with masking fluid that was applied with a sponge.

SUPERIOR, NORTH SHORE
11" × 19" (28cm × 48cm)

Seeing Into Water

Painting the illusion that you are seeing into water is a lot like looking through a Venetian blind. Imagine that the surface of the water is just such a blind—painted blue to reflect the sky. When ripples form on the water, it's like opening the blind. Suddenly, you can see the blind as well as the world beyond through the slits.

This is a wonderful example of the principle of closure, where the viewer perceives whole objects though only a part is shown. Good fun!

1. Mask the Rocks and Paint the Reflected Sky

Use packing tape to preserve objects so you can paint the water freely. Notice that because we are looking down on the objects, you can see the front curves of the rocks as they enter the water.

After the tape that masks the shapes has been pressed down firmly, paint a graded wash from dark blue in the foreground to light blue in the background. This represents a reflection of the sky. Worry about other reflections on the water's surface later. Let dry.

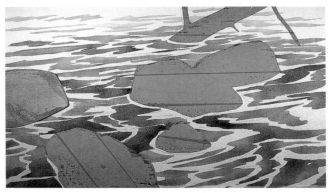

2. Paint the Openings in Your "Blind"

Mix a midvalue, warm greenish brown to represent the color of the water and the bottom that you are able to see through the water. Use a 1-inch (25mm) to 2-inch (51mm) synthetic flat to paint freeflowing and broken zigzags. (The exercise on page 61 will help with these.) Try to make them follow the edges of the protruding objects and key into each other. Make more big dark shapes in the foreground and gradually make them smaller and fewer as you work up the paper. For realism, soften the edges of some of these dark marks as you go with a damp brush. Let dry.

 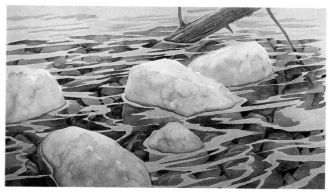

3. Paint the World Below

Now create the scene beyond the blind. Draw in natural extensions of the protruding objects, but only in the green areas. Take advantage of the dark marks to show the edges and junctures of more rocks and sunken treasures.

Working only in the green areas, define the visible edges of underwater rocks by painting an even darker greenish brown mixture around them. Intersections of edges and corners are important. Fade out the marks to make some edges stand out. Work slowly. Keep in mind that, due to lighting, a rock is sometimes painted darker than its background.

4. Add Finishing Touches

Remove the tape from the rocks and log. To paint the rocks, first wet them and then drop in pale yellow, brown, red and blue. Let these colors intermingle. When they get to the damp stage, add drops of water for texture. When this dries, paint a dark line with the same colors along the rocks' (and tree's) juncture with the water. Fade this upward.

To make the blue marks more interesting, paint slightly darker blue marks inside them. With a small scrub brush, lift some highlights from the tops of the underwater rocks.

WET–INTO–WET OPTION
This is an example of what you get if you paint the dark greenish brown marks on the blue reflected-sky background while it's still wet. Everything else is done the same way.

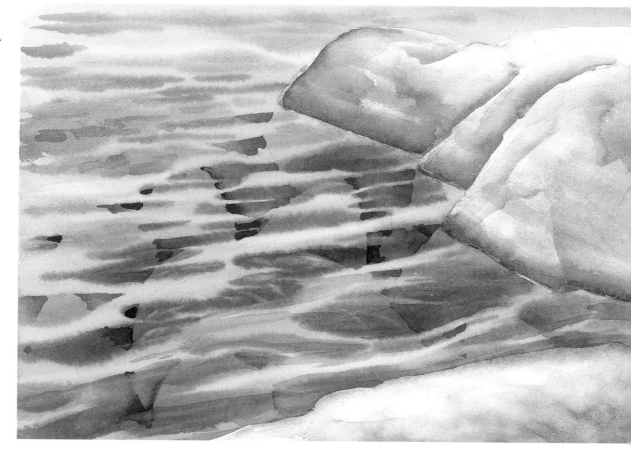

Painting Underwater

No, you don't have to hold your breath for this one, but the results can be breathtaking.

The underwater world is one of phenomenal beauty and one often ignored by painters. There is intrigue, mystery, even fear of what lies beyond our limited vision in this watery world. In fact, it is that unique shallow depth-of-field that characterizes the illusion of being underwater. Only things in the foreground are in sharp focus. The rest are silhouetted and blurry. For painters, that means lots of wet-in-wet painting.

In this world it is common to see shafts of light passing through and striking the upper surfaces of things below. Sometimes underwater structures are darker than their background, sometimes lighter. Regardless, the difference in value between them becomes less and less the further away the structures are.

Color variety is not a big thing underwater. Brightly colored objects are limited to the immediate foreground. Most of your picture will be painted in monochromatic color or analogous mixtures of blues, greens and browns. What is more important than color variety is color value and temperature. Generally objects will be warm and light up close, and cool off and darken in the distance. Water will be lighter near the surface than in the depths.

There is no such thing as one way to paint underwater any more than there is one way to paint above it. This exercise is a generalization of techniques that will help you jump in.

1. Apply Masking

Use packing tape or masking fluid to save foreground shapes that you want to have hard-edged or lighter.

COLOR NOTE

All colors used are transparent. Sap Green, Raw Sienna and Burnt Sienna are non-staining (therefore lift easily), while Phthalo Blue leaves an pale blue after-image because it stains.

2. Begin Background Colors and Shapes

Wet the entire paper. Paint a graded blue wash from dark along the bottom to pale along the top. Immediately use a twisted paper towel to lift off a few light wave lines from the underneath side of the surface above.

While still wet, use a large, flat hog-hair brush loaded with a darker version of the background color to add a few background shapes. Start at the top of the shape and work the color downward until it blends with the background color.

While the paint is still wet, use a large, damp hog-hair brush to lift off the suggestion of a few parallel shafts of sunlight. Start at the top and pull downward. Clean your brush for each stroke and make sure that it is just damp. Don't get carried away. Let dry.

3. Paint Middle-Ground and Foreground Rocks

Paint some middle-ground rocks using a bluish green (Phthalo Blue + Sap Green). Start painting at the top of the rock and then fade downward. Lift off some curved ripple lines with a twisted paper towel. Remove any shafts of light that you want to pass in front of this rock. Let dry.

Remove the masking material, then carefully wet the entire masked area. This will prevent hard edges from forming when you apply a pale brownish green (Burnt Sienna + Raw Sienna + Sap Green) to the entire rock and anchor area.

While still wet, remove light curved and crisscrossing ripple lines from the tops of the rocks with a twisted paper towel. Let dry.

4. Model the Rocks and Add Details

Model the rocks by using a darker version of the three colors used to paint them. Start by darkening the cracks and holes between them and then fading this color upward onto the rocks. Try to avoid covering your ripple lines. When this dries, add Phthalo Blue to the mix and use this to define the darkest shapes and holes between the rocks and the anchor.

Optional Fish
Cut several tiny willow-leaf-shaped holes in a piece of thin acetate. Using your scrub brush and water, lift some of these shapes at random spacing so that they create a flowing pattern. When dry, add a few darker shapes amongst them for fish in the shadows.

HOOKED IN THE PAST
11" × 14" (28cm × 36cm)

Painting Skies

Look up. There are grand atmospherics being staged overhead. The sky is the environmental background for your picture, and as such does much to create the desired mood and drama in your work. Be aware of the unlimited range of choices you have when you make the sky a major player in your picture.

Skies do not normally take a long time to paint. Don't feel guilty and think you have to hang around poking at it for a while. Generally, skies are no place to dilly-dally. Get in, get the paint down and get out. If you want to add more paint, wait for it to dry.

It's important that you use large brushes that can deliver a lot of paint in a hurry with the fewest brushstrokes. It's also useful to have your colors already mixed on the palette so that you don't have to hunt for them during the painting process.

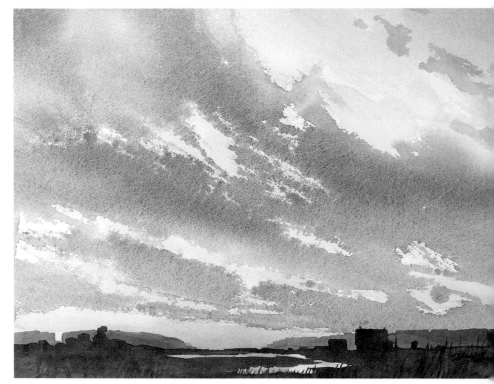

BAR RIVER FLATS
11" × 14" (28cm × 36cm)

MATERIALS USED FOR SKY EXERCISES

Surface
- 140-lb. (300gsm) cold-press paper, mostly 11" × 14" (28cm × 36cm)
- Rigid board for mounting paper

Paints
- Burnt Sienna
- Cobalt Blue
- Indian Yellow
- Indigo
- Lemon Yellow
- Permanent Rose
- Phthalo Blue
- Phthalo Green
- Raw Sienna
- Sap Green
- Sepia
- Ultramarine Blue

Brushes
- ¾-inch (19mm) or 1-inch (25mm) synthetic flat
- 1½-inch (38mm) to 2-inch (51mm) synthetic flat
- ¾-inch (19mm) or 1-inch (25mm) hog-hair bristle
- 1½-inch (38mm) to 2-inch (51mm) hog-hair bristle
- Assorted rounds (synthetic or synthetic/natural mix), nos. 8 to 14

Miscellaneous
- block sponge
- packing tape
- razor knife
- paper towels
- water-filled spray bottle
- small piece of coarse sandpaper

Wet-in-Wet Skies

To make these skies, let paint flow and mingle freely on the wet surface. This works best if you have your colors mixed in pools before you wet the paper. Tilting the surface also gets things moving, but tilting in too many directions will blend everything together and lead to muddy results. *Note:* If you wish to have water or land in your scene, save the hard edge with tape.

TIP

To wet your paper quickly and evenly, use a very wet block sponge. The next best option is a large natural-fiber brush such as hog, badger or goat. Avoid using a synthetic brush because it doesn't carry as much and tends to drop it all in one place.

MOTTLED WET-IN-WET
For the shadows of clouds, paint a mixture of Cobalt Blue + Burnt Sienna onto a wet background. Lay in the color in blotches using a well-loaded, large hog-hair brush. Leave white spaces between your blotches. Notice that a suggested diagonal movement made with brush marks and tilting adds energy to the sky at no extra cost. This process does not take long.

WET-ON-DAMP SKY HOLES
Start as you did for a mottled wet-in-wet sky, but when it gets to the damp stage, quickly paint a few blue sky holes in the white areas. Notice that they are larger near the top of the paper and diminish in size and darkness near the horizon.

WET-ON-DRY SKY HOLES
Start as mottled wet-in-wet, but let it dry before painting the sky holes in the white areas. Create irregular shapes by using the side of a large hog-hair brush well-loaded with blue paint. Soften a few edges as you go with another damp hog-hair brush. Lighten the blue near the horizon.

WET-IN-WET DRAMA

To achieve dramatic contrast, keep the clouds dark along a light horizon. Wet the sky area and brush on juicy, pure strokes of Cobalt Blue, Permanent Rose and Raw Sienna. Let these colors mix on the paper to produce grays in some areas. Use a large brush so that you can move quickly with bold strokes that suggest upward movement in the clouds. While this is still very wet, tilt your board and, using a small brush, carry the sky color down to create the tree-tops of the distant shore by painting the spaces between them. Blot with a rolled paper towel (see page 83) to create rays of sunlight in the sky. Sponge on the dark foreground trees after the sky is dry.

WET-IN-DAMP MOONLIT NIGHT

This uses the same wet-on-damp technique from the previous page except that the colors are darker and a moon is added.

Save the moon first (see diagram). Wet the paper and brush on patches of dark gray for the cloud shadows. While this is still wet, paint the dark sky color (Indigo + Cobalt Blue or Ultramarine Blue) using a well-loaded hog-hair brush. Place this dark color in the white areas between the cloud shadows, particularly around the moon. This color will flow toward the gray but leave a halo of white around the clouds. When the sky is dry, glaze a wash of blue-gray over the entire clouds that are farthest from the moon. Fade out the glazing as you approach the moon. This leaves the greatest contrast around the moon.

In this example, the sky color is also used for the water. Sparkles were made by sanding the water when it was completely dry (see diagram). The darker land is a mixture of Indigo and Sepia. Remove the masking from the moon and, if you wish, pick out a few stars with the tip of a razor knife.

SANDING FOR WATER SPARKLES

This isn't a sky technique, but you may wonder how the water sparkles were created in the painting above. Using a ruler as a horizontal guide, press down hard on a small piece of coarse, folded sandpaper positioned against the ruler. Drag it quickly along the ruler to create your sparkles. It may take several swipes to remove enough paper. Work your way down the paper. Use a soft eraser to clean the area.

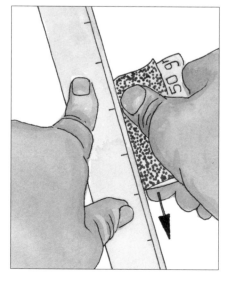

SAVING THE MOON

Place a coin over a small piece of packing tape where you want your moon to be. Gently cut around the coin with a razor knife. Remove the coin and excess tape, and press the moon shape firmly.

Making Cloud Bottoms by Fading Out

When heavy clouds roll in, they're often so thick that all you see are their bottom sides.

1. Paint the Cloud Bottoms

Mix a gray from Cobalt Blue + Raw Sienna. This gray can be cooled with more blue or warmed with more brown. Make an irregular mark across your paper to represent the bottom of a distant cloud. Fade this upward with another damp brush. Let dry.

2. Add More Clouds

Repeat the process in step 1 with more clouds, letting them dry between applications. Vary the width and length of each cloud mark.

3. And a Few More

As you work your way up the sky, the clouds should normally become larger, warmer and darker. Their edges also become more irregular. Let dry.

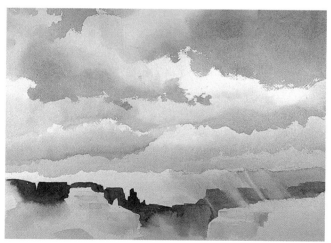

4. Add Sky Holes

Some pure blue sky will make a good contrast against all the grays. Try some if you'd like. The sky under the clouds will probably be a warm white (pale Raw Sienna).

Rain

If you want distant rain falling, paint some of the sky underneath the clouds a dark, cool gray. Fade this out along the horizon and, while wet, lift out some streaks with a damp brush. When this dries, paint the land so that it fades out into the rain cloud.

Making Billowy Clouds

Here are two techniques for painting billowy clouds. If you look at the clouds in the photo, you will notice that in some places the billows are light against a darker background and, in others, dark against a lighter background. Each is painted in its own way.

LIGHT BILLOWS AGAINST A DARKER BACKGROUND

These types of clouds will give you plenty of practice fading out color. It's also the rare occasion when you will be doing a lot of brushwork in the sky. The challenge is to make it look as if you hadn't.

Sooner or later you are going to realize that you are doing the same thing over and over again. This is the same process used to paint the bottoms of clouds on the previous page. The only difference is how you look at it. Now, the bottom edge of the dark mark defines the top of a light billowy cloud below it.

The gray used for the cloud shadows is a very pale mixture of Cobalt Blue + Burnt Sienna or Raw Sienna.

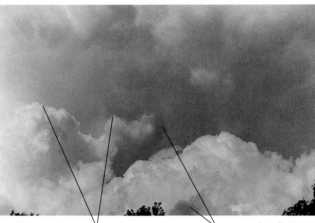

CLOUDS LIGHT AND DARK
Sometimes clouds are light against a dark background, and sometimes vice versa.

light against dark dark against light

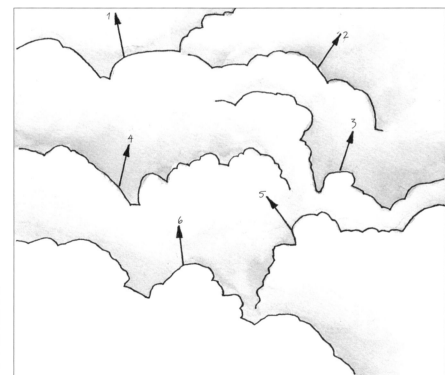

THINKING THROUGH THE PROCESS
Start with the billows at the top of the cloud mass and work your way down. Don't try to plan where each billow will go; place them where they feel right. Focus on making the bottom edge of your mark as irregular and interesting as possible because it will become the top of another cloud. Try to make a conscious effort to vary the length, width and position of the marks and the distance between them. If your sky looks like a squadron of flying snakes, you don't have enough variety and you are not likely fading out each mark appropriately.

You will notice as you work your way down the paper that one mark will often fade upward and partially obscure the mark above. That's okay; it adds to the realism and variety. Give the impression that your clouds continue right off the paper instead of trying to neatly contain them within the picture plane.

TIP

Since this fading-out process is also a dandy way to paint mounds of snow, foam on water or trees on a hillside, mastering it would certainly be to your benefit.

HEIGHTEN THE DRAMA

Extra drama and contrast can be created by using darker gray on some of the bottom clouds. A touch of blue sky defines the top of the cloud mass, while dark trees put everything in perspective.

ADDING SHADOWED CLOUDS ON THE HORIZON

Paint light, billowy clouds as before, but leave a light area near the bottom of the sky. When this is dry, paint the silhouette of shadowed clouds on the horizon with the same blue-gray used for the first part. When this dries, add billows to these clouds with more blue-gray.

A STORM-FRONT VARIATION

Instead of adding more billowy clouds along the horizon, you could add a storm front. To do this, sweep in a dark layer of blue-gray clouds from the horizon up. Use the side of a large, well-loaded hog-hair brush.

To add to the illusion of an approaching rainstorm, paint some dark land or hills while the darker gray clouds are damp. Immediately use a damp hog-hair brush to lift falling rain marks from the clouds and land by stroking from the horizon up.

DARK BILLOWS AGAINST A LIGHTER BACKGROUND

Unlike the toplit clouds where entire billows are created one at a time, the billows on these front-lit clouds are painted one *cloud* at a time. Your picture will likely have more than one cloud, and each is treated separately.

Again, the grays used for the cloud shadows are made with a very pale mixture of Cobalt Blue + Burnt Sienna or Raw Sienna. The process seems to work best with a synthetic round brush no. 12 or larger.

1. Prepare the Cloud

Thoroughly wet the shape of a single cloud. Drop paint along the outer edges of the wet area using a no. 12 synthetic round loaded with a concentrated blue-gray. The color will diffuse into the wet area, leaving a dark, hard edge to the cloud. Vary the width of this shadow area by dropping more paint in some areas than in others.

2. Leapfrogging Magic

Continue painting with the same brush without reloading it. Start picking up paint from the dark edges and carry it in toward the white, wet center of the cloud using continuous leapfrog-type strokes. These marks that mimic the edges of cloud billows produce tiny, soft, subtle billows on the face of your cloud. The front-lit illusion is strengthened when your paint gets lighter and lighter as your brush runs out of pigment toward the center of the cloud.

As an option, try placing a drop of clean water in the light billow centers when the paint dries to the damp stage. This can create some interesting backruns and feathered edges in your clouds. Don't worry about the bottom of the cloud at this point.

Develop the cloud's form with leapfrog strokes.

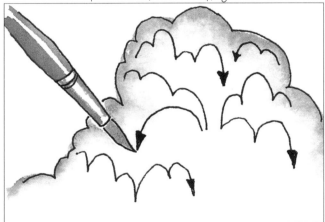

What the result looks like

3. Add More Clouds, Background Sky and Cloud Bottoms

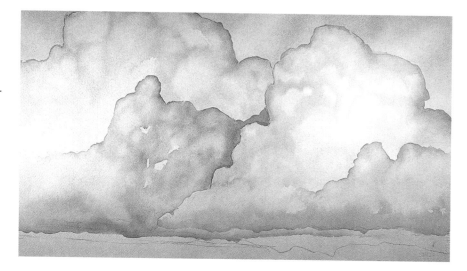

Add More Clouds
Paint more clouds using the procedure from steps 1 and 2. You will find it easier to work from foreground clouds to background clouds. I intentionally warmed up the background clouds just to show you that the temperature of these clouds can vary. This is particularly true of the clouds are bathed in the warm accent light of evening or morning.

Add Background Sky
If you wish to have an even color for the sky, first wet the entire sky area and then add concentrated color with a 2-inch (51mm) flat synthetic or hog-hair brush. Carefully paint to the edge of the clouds. Tilting helps distribute color evenly.

If you wish to have cirrus clouds high in the background, paint the sky as if it were solid blue and then invert, tilt and spray it with water in a couple of areas near the top of the clouds. The paint will flow off the paper, leaving the light streaks of cirrus clouds in the background.

Add Cloud Bottoms If Desired
It is not always necessary to show the bottoms of the clouds. For example, if you want a dramatic storm on the horizon, paint your hills and trees where the bottoms would be.

If you do want bottoms on your clouds, paint them the same as the tops by first wetting the area, dropping paint along the edge and working it upward. The only difference is that the bottoms are flatter. Clouds in the background will have bottoms that are lower in the sky than the foreground clouds.

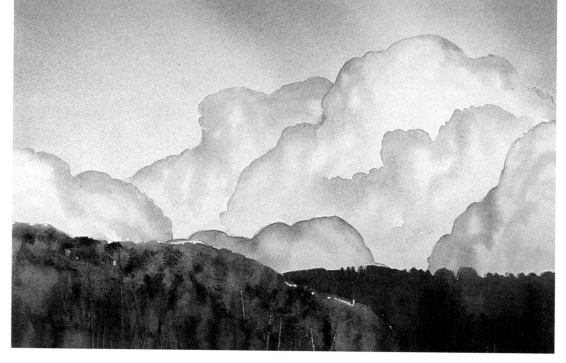

A DISAPPEARING ACT
Land can obscure the bottoms of clouds.

Graded Washes

A graded wash makes a great sky on its own or is the start for many others. The trick to smooth color gradation, if that's what you want, is to tilt your board so that gravity and the water can do the work. As usual, work quickly with a large brush, and make strokes that go right off the paper.

1. Start With a Graded Sky

Every sunrise or sunset is different. About the only consistent feature is the gradation from cool color to warm as you approach the sun. In this exercise, gradate the pale background wash from Cobalt Blue at the top to Permanent Rose, then to Indian Yellow.

2. Add Graded Clouds

Gradate the clouds cool to warm, but make them duller and darker than the sky. Mix all three sky colors to make a mauve-like gray. Use this for the top clouds. Gradually work your way down, adding more clouds. As you go, first pull more red into the gray mixture, then more yellow. For a smoother gradation, don't clean your brush each time you add a color. For more realism (thanks to the pollution level), darken the horizon area with more dulled mauve.

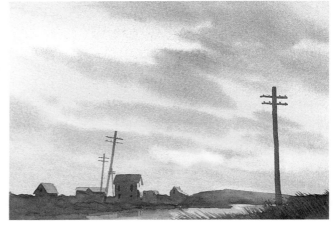

3. Add the Final Touches

While still damp, paint a few strokes of pale Lemon Yellow in the sun area and for highlights under the clouds. The contrast of adding dark land will make the sky seem brighter.

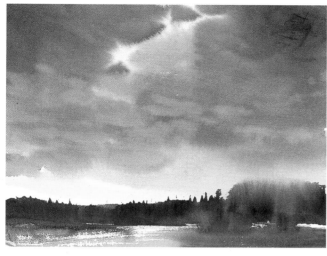

GRADED CLOUDS ON A TONED BACKGROUND
Wet the sky area. Add Raw Sienna near the horizon and fade this out upward to just clean water at the top. While this is still wet, use a large, flat hog-hair brush loaded with concentrated, dark blue-gray (Cobalt Blue + Burnt Sienna) to brush on the clouds. Gradate from large, dark strokes at the top to smaller, paler strokes near the bottom. (This happens naturally as you run out of paint.) Leave some of the pale yellow sky showing.

When this dries to damp, highlight the open sky and undersides of the clouds by touching them with the corner of a hog-hair brush loaded with pale yellow-orange (Indian Yellow + Permanent Rose). Land can be added now or later for contrast by using dark, concentrated sky colors.

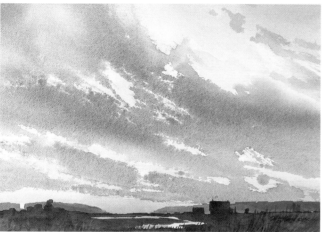

DRYBRUSHING OVER A WASH
Paint a pale graded wash from Raw Sienna at the horizon to Cobalt Blue at the top. Add a hint of mauve (Permanent Rose + Cobalt Blue) near the horizon. Let dry.

Mix two puddles of gray using Cobalt Blue + Raw Sienna: one a bluish (cool) gray, the other a brownish (warm) gray. Load a large hog-hair brush with either one and repeatedly drag it on its side across the sky to create a bold, lacy pattern. Following a sweeping diagonal will add dynamics to your picture.

Immediately pick up some of the other gray and repeat so that the grays blend here and there. Softening edges with another damp brush will add realism. Painting distant hills a blue or mauve before doing the foreground will add depth to your scene.

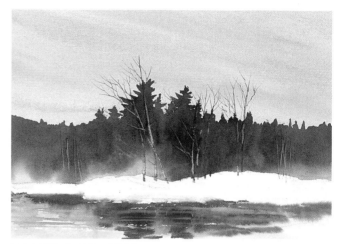

HOT-IN-COLD WASH
Instead of doing a progression of colors for a background wash, start by giving your sky a consistent wash of midvalue Cobalt Blue. Immediately reload your brush with any yellows, pinks and oranges and stroke this across the blue. It will push the blue aside and take on a wonderful glow.

For the sake of harmony, use dark, concentrated sky colors for the land and reflections.

Lifting Paint

Sometimes removing paint from a
picture is the best way to achieve
results. In both examples below, a
rolled paper towel was used. See
page 83 for how to roll and hold
the towel.

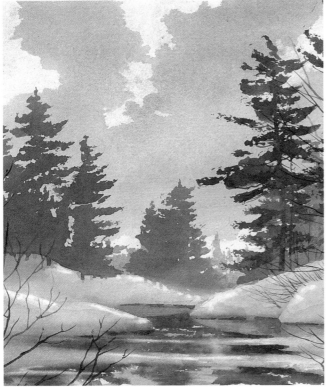

LIFTING COLOR FROM A GRADED WASH

These are the clouds caught in the glow of early evening
or morning before the sun is in the sky. Use nonstaining
colors (Cobalt Blue, Raw Sienna, Permanent Rose) to paint
a graded wash from cool blue above to warm hues near the
horizon. Immediately create holes between clouds by blotting
with a rolled paper towel. To take off big areas, roll the
towel across the surface. Work quickly and reposition your
towel continually so that a clean portion is always being used.
The light holes should have a slight blue cast.

In case you didn't realize, this is negative painting,
except you are removing paint instead of adding it.

Trees were painted with Phthalo Green and Burnt
Sienna using a torn piece of cellulose sponge.

LIFTING SILVER LININGS

Start with a loose, mottled wet-in-wet background using
Cobalt Blue with a hint of Raw Sienna. (Any nonstaining
colors will work.) While this is still wet, remove paint in
an irregular line by blotting with a twisted paper towel.
The light shape represents the light breaking through the
clouds, or the clouds' "silver linings." To improve the illusion,
darken the clouds that are silhouetting some of the edges
of this light patch. The darker you make these edges, the
brighter the light patch will appear. In other areas of the
blotted shapes, blend the edges into the surrounding clouds.

Lifting Color for Northern Lights

It is possible to capture the gossamer nature of northern or southern lights by lifting paint with a flat synthetic brush.

1. Prepare the Background

Start by mixing a large batch of very dark color (e.g., Indigo + any blue or Permanent Rose + Phthalo Blue and Sap Green).

Since you may need extra time to work on this exercise, I suggest working on a waterproof surface and wetting both sides of your paper. Don't bother taping it down since the water will make it adhere it to the surface.

Apply your color liberally to your paper using a large hog-hair brush. Leave narrow, curved light areas between strokes.

2. Lift for the Lights

While still moist, use a large, damp synthetic brush to extend the light areas upward. The trick is to hold your brush on the light band for a couple of seconds before dragging it up ward. This allows the brush to pick up more color at the start which produces a light bottom on the band. Repeat this process of lifting color with vertical strokes as you work along the light band. Keep your brush clean and damp. While the sky dries, pick out some stars with the tip of a razor knife. Paint the tops of the hills and trees and fade these downward into the night.

Variation: Try this on a piece of paper that has been toned pale yellow-green and let dry.

Spraying and Tilting

Here's a quick, fun way to create a dynamic background for a sky. This process does not take long; you must move quickly and avoid overworking. The key to success is how you spray and the type of spray bottle you use.

SETTING THE STAGE
With a big, well-loaded brush, put down a heavy mass of dark paint along the top or bottom or across the middle of the sky. Leave at least 50 percent white.

SPRAYING AND TILTING
Apply a coarse spray of water along the edges of the dark areas. Tilt the paper to direct the flow back and forth. Try to maintain the same direction of flow. Spray more as necessary to keep things moving. Stop while you still have lacy patterns trailing across white paper. Lay it flat to dry.

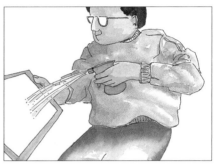

SPRAYING NOTE
To get a coarse spray, go lightly on the trigger and keep your distance. Pretend that you are making it rain on the paper. Do not use a small atomizer for this job. For good types of sprayers, see page 20.

DROP IN A "LAND-SHAPE"
This is a great example of how almost anything will do for a sky. Here I dropped a lake scene "land-shape" in front of it. A land-shape is the land portion cut from an old picture. In sky workshops I keep a few on hand so that students can instantly see how great their skies really are once they are shown as the atmospheric back-drop they are intended to be. Make some of your own.

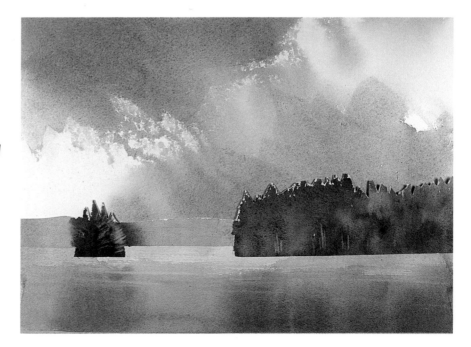

Dropping Water or Paint

These are some of the simplest skies to paint. Start by wetting the sky area and laying in a graded wash with a nonstaining color.

When the surface starts to lose its shine, load a large brush with water or paint and let it drip off the brush onto the paper. The water will expand on the wet surface to resemble closely packed clouds, producing a wonderful mottled sky.

For the sake of perspective, try to make the drops at the top of the sky big and the ones near the bottom small.

DROPPING WATER ON COLOR
The background for this sky was a graded wash of Cobalt Blue to Raw Sienna. While the wash was still damp, I dropped in water to create the cloud effect.

DROPPING COLOR ON WATER
When the clouds are in front of the sun, they appear darker than the sky. I wet the entire surface, then loaded a large brush with a pale gray and dropped in color by just touching the brush to the wet surface. The drops of color expand but leave a light line between each one.

DROPPING AND TILTING
Here, I laid the drops of water in vertical rows. Tilting the paper flowed them together in streaks

REPEATEDLY DROPPING WATER
Here, I repeated the process of dropping water into the paint several times. Each time I waited until the paint dried to the damp stage before adding more drops of water.

Painting the Land

This part of the chapter examines various aspects involved in painting the land. It is your job to take the examples used here and, if necessary, modify them to suit your corner of the world. After all, you are the best authority. But first look here for the underlying lessons in procedure or technique that may help you see and capture your own unique view of our natural host.

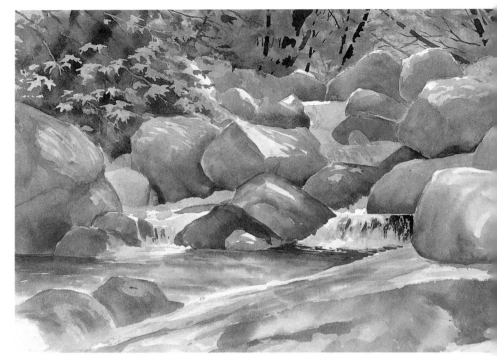

WATER MUSIC
15" × 22" (38cm × 56cm)

MATERIALS USED FOR LAND EXERCISES

Surface
- 140-lb. (300gsm) cold-press paper, mostly 11" × 14" (28cm × 36cm)
- Rigid board for mounting paper

Paints
- Burnt Sienna
- Cadmium Orange
- Cadmium Red Light
- Cerulean Blue
- Cobalt Blue
- Indian Yellow
- Indigo
- Lemon Yellow
- Permanent Rose
- Phthalo Blue
- Phthalo Green
- Raw Sienna
- Sap Green
- Sepia

Brushes
- ¾-inch (19mm) or 1-inch (25mm) synthetic flat
- 1½-inch (38mm) to 2-inch (51mm) synthetic flat
- ¾-inch (19mm) or 1-inch (25mm) hog-hair bristle
- 1½-inch (38mm) or 2-inch (51mm) hog-hair bristle
- Assorted rounds (synthetic or synthetic/natural mix), nos. 8 to 14
- Any size rigger or script liner
- Small scrub brush (To make one, see page 16.)

Miscellaneous
- vinyl glove
- razor blade
- stiff palette knife
- razor knife
- cellulose sponge
- water-filled spray bottle
- thin sheet of acetate
- pencil
- eraser
- masking fluid
- rubber cement pickup
- toothbrush
- packing tape
- paper towels
- scrap paper

Rocks

There are a few ways to handle this common landscape feature. In most examples, the rock area is textured or patterned in some way and then cracks and modeling are applied.

FIST AND SCRAPE
This technique that works for tree trunks works even better on rocks.

1. Get Right Into the Paint

Paint the rock mass a medium-to-dark gray. Immediately push the edge of your fist or knuckles into the paint. I recommend wearing a vinyl glove for this.

2. Start Scraping

While this is still damp, use a razor blade or palette knife to scrape back the top surface of rocks. Make sure they coincide with the outside contour of the rock mass.

3. Brush Details

After you have washed your hands (if you didn't wear a glove), use a darker form of the gray and a fine brush to paint the deep cracks and to emphasize light edges.

SPATTERING FOR BEDROCK

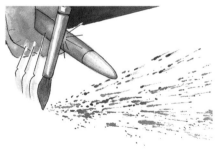

SPATTER TECHNIQUE
Load a large brush with color and gently tap it on another brush handle. Do it at a low angle so that the spatter fans out across the paper, giving direction to the texture.

Be warned: This can get really messy because of the kickback spray that goes all over your paper. Protect nonrock areas with paper or tape.

1. Spatter the Background Colors

Sketch your rocks and then paint over with a pale, mottled Cerulean Blue/Burnt Sienna wash. Let dry. Spatter with pale and concentrated forms of the same two colors.

2. Add Cracks and Shadows

Paint the shadows and cracks for the rock with the same two colors mixed. Paint irregular lines and fade each upward from the crack. Repeat with darker concentrated color to deepen the crevices.

BEACH STONES

Here's an approach that was also used for clouds.

1. Play Leapfrog

For this mottled background, mix any concentrated gray from a triad and apply it with a round brush in random "leapfrog" fashion (see page 96) all over a damp rock area. Don't try to follow the rock shapes. Stop while there are still light areas left in the pattern.

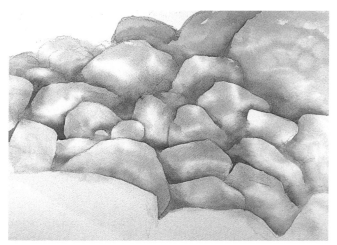

2. Define Rocks

Define one rock from another by outlining them with a more concentrated gray and fading out into the rocks behind. Work from the bottom up.

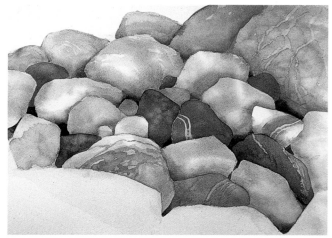

3. Refine Rocks

Darken some of the rocks. Glaze a hint of different color on others. Create veins by direct positive and negative painting as well as painting and scraping with a palette knife. Try water spots, too. Redarken the deepest crevices.

Reflected Light on Rocks

This is one of the most dramatic effects to use with rocks. You will capitalize on how warm reflected light can illuminate areas that are in shadow and give the impression that the objects themselves are giving off light.

PAINTING THE COLOR OF REFLECTED LIGHT

To create the effect of rocks that are bathed in reflected light, you must blend cool and warm colors on the shadow side of the rock. A band of pale, cool color (blue) is painted near the top of the rock and a pale, warm band (orange) is painted along the bottom. In the middle, where the two meet, blend them together to produce a gray. Fade out the top edge of the blue band.

1. Gradate It

Work one rock at a time until all have a gradation from cool near the top to warm at the bottom. Let dry.

2. Glaze It

Darken the edges and the shadow side of each rock by glazing with a warm gray. Texture with water drops while this layer is still damp.

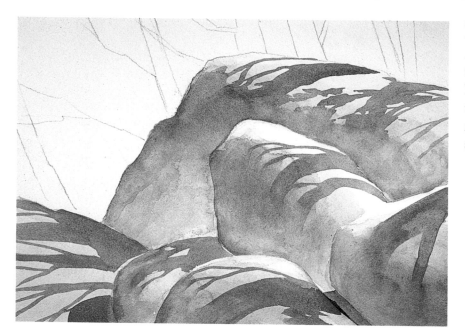

3. Shadow It

Add cast shadows using a flat synthetic brush and a dark, cool gray. Notice how the cast shadows of the trees out of view blend into the rocks' shadows on the shadowed side.

Trees

Trees are like actors in the cast of a play who bring energy and reality to the performance. They will perform for you in your paintings as well if you take the time to make them look believable and position them so that they can best play the role intended for them.

Making trees look believable has a lot to do with understanding that the primary function of the trunks and limbs is to reach up and out far enough to hold their leaves in the sunlight. All species do this in their own way, but it wouldn't happen if the trunk, branches and twigs didn't graduate in size as they got farther away from the base. Your tree won't look very real either if the branches don't quite connect or are over-lapped at a joint.

GROWTH PATTERNS

The problem that most people have with making trees is that they are still influenced by the icons for "tree" that they developed as a child. It is time to look at trees with a more critical artist's eye. What you will find are a couple of common, simple growth patterns. By seeing and following these patterns, you can improve the character and believability of the players on your stage.

Deciduous and coniferous trees have their own patterns, each affected by age and environment. With age, trees exaggerate their growth as if celebrating their survival. Bases broaden and limbs thicken, twist and distort as they extend their reach. If growing by themselves, they

will reach a fullness of shape. But in the close company of other trees, they will shift their energy to the upper limbs and take whatever shape is necessary to perform their primary function. And, of course, in the face of strong prevailing winds, there is also distortion that mimes the wind itself.

In time, you will discover how each species is a variation on the patterns to follow. Many species fit into the same growth pattern, and the same species can fit into more than one pattern. For example, a maple may have a single central trunk when young but evolve with multiple trunks as it ages, or grow to have everything at the top if it's in a dense forest.

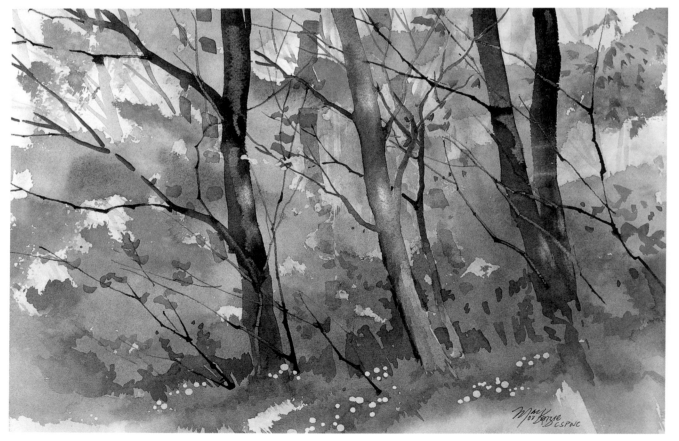

SUMMER RESPITE
11" × 14" (28cm × 36cm)

Deciduous Trees

SINGLE VERTICAL TRUNK

Here a central trunk supports branches that tend to head outward before turning upward. The lower branches turn down.

Start by painting a single tapered line from the ground up (red). If this main trunk isn't perfectly straight, it will have more character. Make changes in direction, abrupt or smooth. Use a round or flat synthetic brush or a broad-tipped palette knife.

To this trunk, add a few tapered branches (blue) that grow upward and outward in the same style as the trunk. The width and height of the tree is up to you. Use a broad rigger, fine-tipped round brush or broad-tipped palette knife.

To your branches, add smaller branching limbs (green) to fill out your tree into whatever shape you want. Be consistent with the style of your branches. Use a rigger, a fine round synthetic brush, a sharpened stick or a fine-tipped palette knife.

TIPS

1. Regardless of species, branches are a lot longer than you think they are. Let them run off the paper, and don't forget the ones that grow downward.
2. Pay attention to the angles at which main trunks and branches meet each other as well as their general placement (i.e., opposite or random). There is a consistency in each tree.
3. The shape your tree takes is up to you, but very few are perfectly symmetrical.

MULTIPLE TRUNKS

In this pattern, more than one vertical trunk either grows from a single base trunk or leaves the ground as a clump. Start with the main trunks (red), which tend to branch upward (blue) before adding smaller limbs (green) that reach outward and down.

DECIDUOUS TREE VARIATIONS

Sometimes the main trunk is contorted because of the species, its age or weather conditions. As before, start with the main trunk (red) and then add branches (blue, green) that suit the character of the trunk. Sometimes branches head down, as in "weeping" types of trees.

Painting Deciduous Foliage

You will paint better deciduous trees when you understand the structure within them. In most cases, it's best to paint the foliage of a deciduous tree before the trunk and branches, but that shouldn't prevent you from lightly sketching in their locations as a guide for the foliage if it's important for the composition.

Below are just a few ways to add foliage. Try to paint not individual leaves but clumps, and don't forget to leave spaces between the clumps for birds to get through. Generally speaking, the top of the tree is lighter and warmer than the underside. Add details, branches and the trunk after the paint is dry.

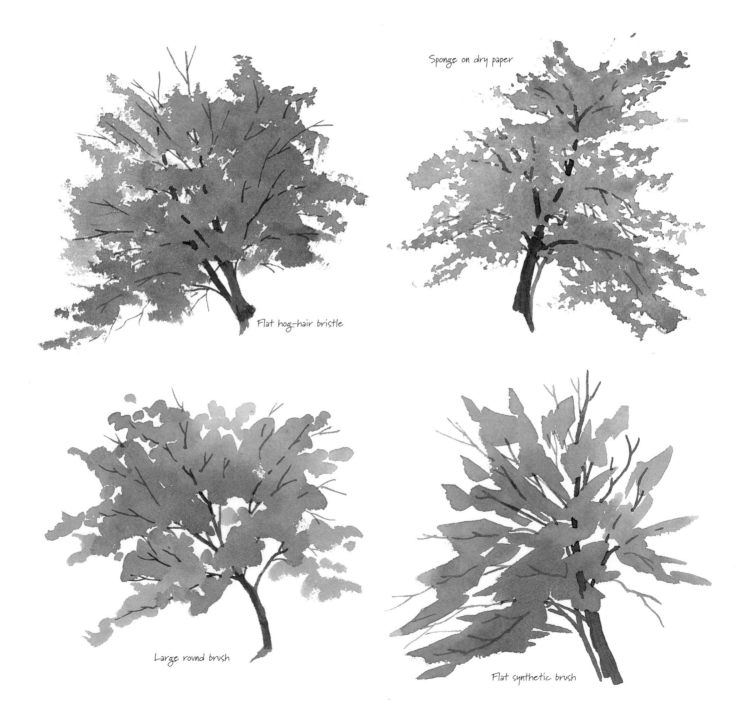

Flat hog-hair bristle

Sponge on dry paper

Large round brush

Flat synthetic brush

Branching Options

The style of branches in your picture conveys a subtle message to the viewer. Are your limbs from haunted forests or a tranquil garden? Are they carrying life or remnants of a former day?

ANGULAR

If you wish to have twisted or sharp angular branching on your tree, try using a rigger or a palette knife. Make the main branch with numerous stops. At each stop, change direction. From each subsequent bend, start another angular branch, and from those angles extend more bent twigs. This type of branching is most common on deciduous trees.

SMOOTH FLOWING

If you want less agitation in your branches, soften the bends. Smooth branches with low-angled joints to give a different feel to your work, regardless of species. These can be made with a round brush, rigger, script liner or palette knife.

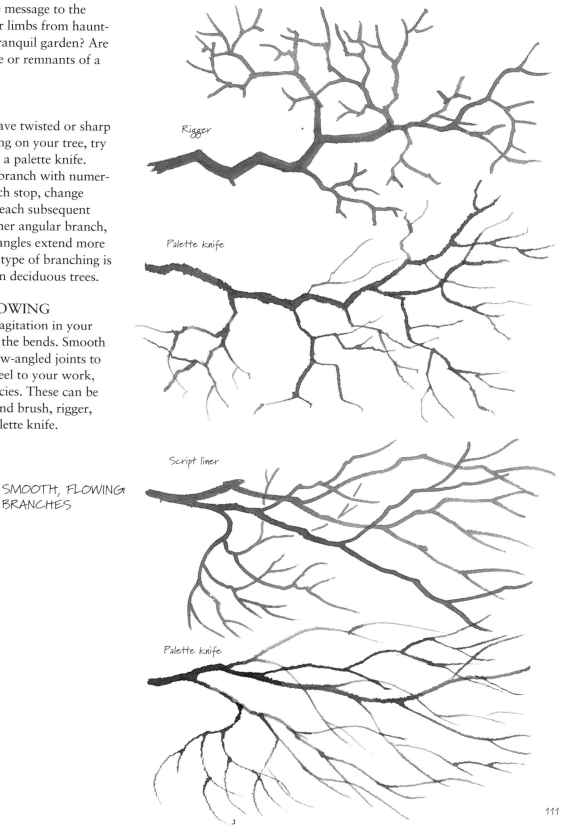

SHARP, ANGULAR BRANCHES

Rigger

Palette knife

Script liner

SMOOTH, FLOWING BRANCHES

Palette knife

Coniferous Trees

Although we rarely paint a coniferous tree without its needles, it is nonetheless important to understand its underlying structure. These trees develop around a single central trunk that is usually straighter than deciduous types. It's also important to get the angle of coniferous branches correct. Branches at the top head upward, those in the midsection head outward and then upward, and those near the bottom head downward and then upward. Coniferous branches tend to be shorter, and most branch out flatter than deciduous ones (which allows for space between the branches). Branches on some trees grow out of the trunk nearly opposite each other.

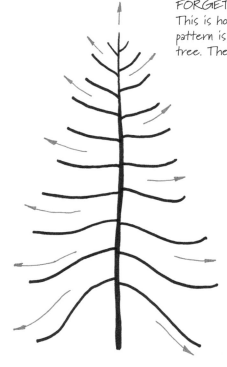

FORGET YOUR CHRISTMAS TREE ICON
This is how a coniferous tree really grows. The pattern is the same regardless of the type of tree. The limbs grow up and out, not down.

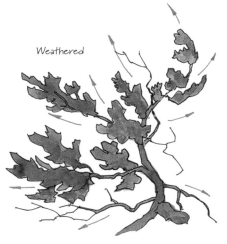

Weathered

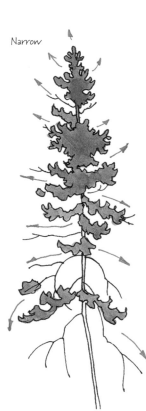

Narrow

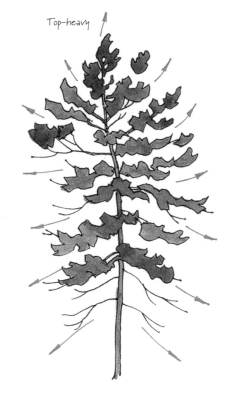

Top-heavy

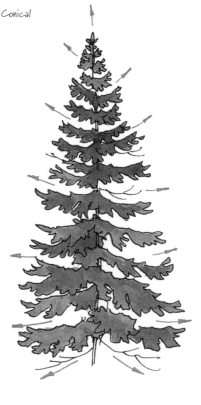

Conical

Painting Coniferous Foliage
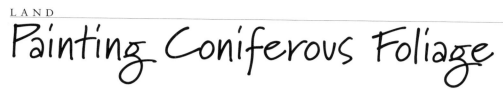

Coniferous trees can be painted with a variety of tools and techniques.

SPONGES
One good technique for creating coniferous trees is to paint them with the edge and tip of a piece torn from a synthetic sponge. Start from the top and work down. Occasionally flick the sponge upward to create the effect of needles. Add the trunks after the foliage is painted.

BRUSHES
Each type of brush you have will create a unique tree. Again, start from the top and work down. Add the trunks after the foliage is painted. Flicking a bristle brush upward will suggest clumps of needles.

PALETTE KNIFE
You can also drag the edge of a palette knife that has been loaded with concentrated color across a page sprayed with water. Start by making the trunks and then drawing (well, dragging) one branch at a time. Keep reloading your knife with dark color because the sprayed water will dilute it.

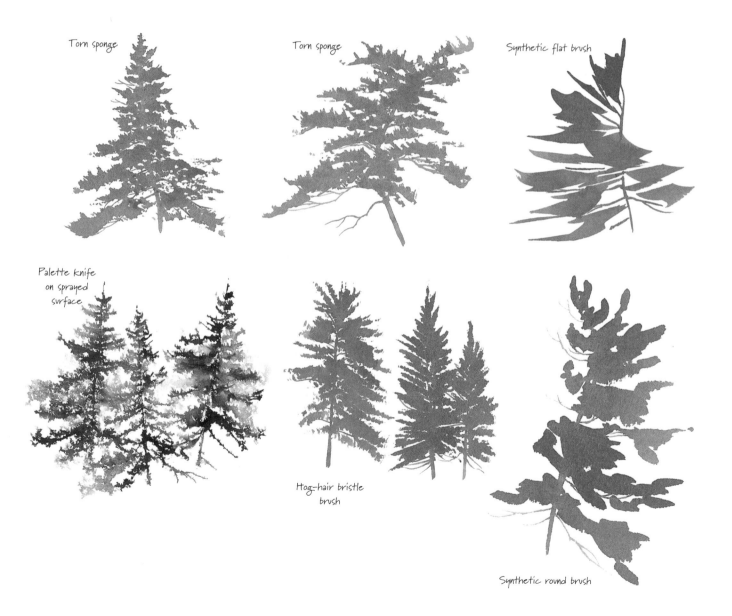

Torn sponge

Torn sponge

Synthetic flat brush

Palette knife on sprayed surface

Hog-hair bristle brush

Synthetic round brush

Palm Trees

Sometimes because of age, crowding or species, the leaves or fronds of a tree grow only at the top end of a single trunk. This is the case with most palm trees. For example, the fronds of the coconut tree arch in a radiating pattern, like exploding fireworks.

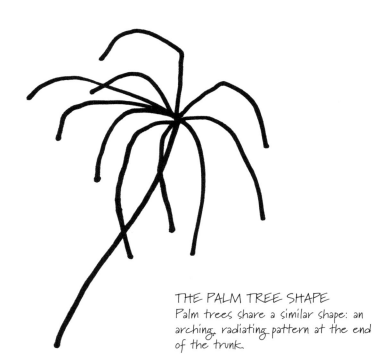

THE PALM TREE SHAPE
Palm trees share a similar shape: an arching, radiating pattern at the end of the trunk.

A TROPICAL PLANT SAMPLER
Notice how many branches or fronds radiate from a line and/or a center. This is a common tropical growth pattern.

PAINTING PALM FRONDS

Paint your palm trees one frond at a time, using a script liner or round brush and a range of warm and cool greens. Start by painting a fine center line for the frond and then painting the blades with repeated strokes from that center line outward. Keep the general direction of the blades angled toward the front of the frond. The leaves of the banana plant are painted with a small, flat synthetic brush with spaces left between some of the strokes. The palmetto palm has blades that radiate from the tips of the stems.

PAINTING THE SIDE VIEW

Sometimes, only one side of the frond is visible. In this case, paint the fronds dark and then scrape back a few light ones with a palette knife or a narrow slice of a defunct credit card when damp. After most of the fronds are painted, add a few darker ones in the underneath shaded part of the tree.

A STENCIL FOR PALM FRONDS

Cut a paper stencil that follows the center line of your palm frond. By painting off this stencil, you create blades that start along a very precise line. Do the opposite side of the frond with the other piece of the stencil. The problem with this method is that you'll be cutting a lot of stencils and waiting until each side dries before doing the next. This gives you precision at the price of spontaneity.

Combining Techniques for a Meadow

One simple technique with a hog-hair bristle brush allows you to make grassy fields with ease, while another technique with a flat synthetic brush creates individual blades of grass.

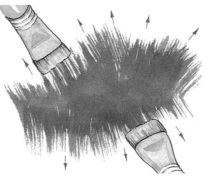

HOG-HAIR BRISTLE TECHNIQUE FOR GRASS CLUMPS
Hold your loaded brush vertically. Make sweeping strokes upward to represent dark positive blades of grass and downward to create light negative blades.

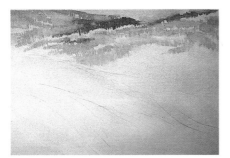

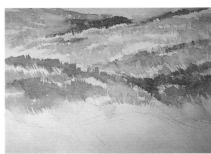

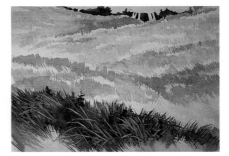

1. Begin in the Distance

Paint a graded wash from pale Cobalt Blue in the distance to yellowish green in the foreground. Let dry.

In the distance, make short strokes up and down with a pale, cool, dull green (Phthalo Green + Cobalt Blue). Leave spaces between clumps of grass as you follow the terrain. Darken some areas, fade out others.

2. Move Forward

As you get closer, add more Sap Green and Burnt Sienna to the mixture and make your strokes longer and varied. Continue to make some patches lighter and others darker, and don't forget to fade out occasionally.

3. Add Foreground Blades

Use a green mix (Phthalo Green + Indian Yellow + Burnt Sienna) to paint an irregular dark patch of grass in the foreground. When this dries to damp, lift some light blades with a damp, 1-inch (25mm) synthetic flat. Work quickly and keep cleaning your brush. Add darker blades of grass and weeds. Try a bit of negative painting for variety and contrast. Add a background forest.

4. Finish the Details

Help model the field and add to the range of greens by glazing pale blues for valleys and yellows for highlights over the meadow. Reinforce perspective by adding something in the foreground, such as fence posts.

VACANCY
11" × 14" (28cm × 36cm)

Ferns

This simple process can be repeated over and over to create a field of ferns. In fact, it can be used to paint fields of any objects that are stacked up against each other. What is important is that you work through the steps quickly. Developing shapes this way is a perfect example of how an object can be both positive and negative. You will see a similarity between this and the previous meadow exercise.

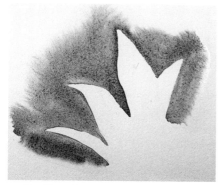

1. Define the Shape

Paint around the basic shape of a clump of ferns with a good load of paint.

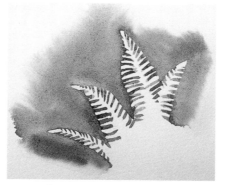

2. Refine the Shape

Immediately draw some of the wet paint toward the center line of the fern using a fine-tipped brush. You are painting these ferns in the negative.

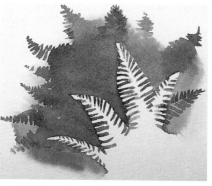

3. Define the Background

While still wet, load your fine-tipped brush with more color and extend the background paint into the positive ferns.

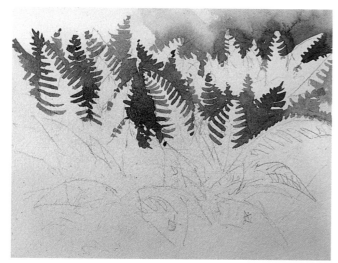

STARTING A FIELD OF FERNS
In a real picture you may wish to sketch the rough location of ferns before painting a light wash of greens over the background. After that dries, you would then paint the light ferns in the middle ground with a row of cool, dark-green ferns behind them, varying the angles of the fronds. Next, you would paint the row of background ferns. These are only painted in the negative, with the background color faded out. A cooler (Phthalo) green was used here.

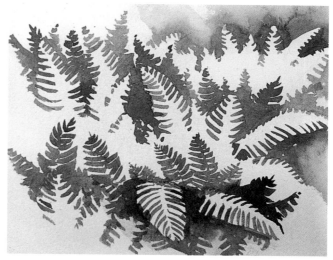

FINISHING THE FERNS
You would reverse the process in the foreground, starting with the dark positive fronds at the back of the clump and working the color down and around light fronds in the foreground using a warmer (Sap) green.

Tree Trunks

Sooner or later, you're going to have to get close to a tree. Here are four ways to handle their surfaces, but there are lots more ways for you to invent.

TRUNK VARIATION #1
First paint the trunk with dark, nonstaining color. When this dries to the damp stage, add large drops of water up the center of the trunk. When this dries to damp again, blot the entire tree. The trunk will be dark around the edges. Add line detail when everything is dry.

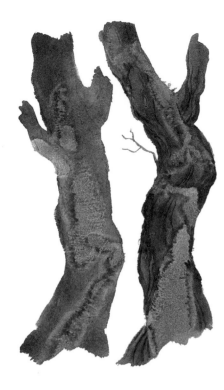

TRUNK VARIATION #3
Paint the trunk in dark colors. As the shine leaves the paper, press the edges of your fist and knuckles into the paint (you can wear vinyl gloves if you like). When this dries, add darker details.

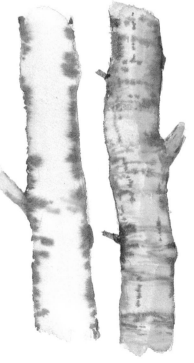

TRUNK VARIATION #4
First, paint the trunk a pale warm color. When it dries to damp, run a fine-tipped round brush loaded with dark color along the edges. Carry the color as dots and lines across the trunk. Add shadows when dry.

TRUNK VARIATION #2
First, paint the trunk with a dark color. When this reaches the damp stage, scrape with a palette knife. Add pale blue shadows when it dries.

Tree Lines and Seasonal Forest Scenes

When you look at a forest, you only see the hint of individual trees. Our objective in these exercises is to create the illusion of a forest without a whole lot of work. You will have an opportunity to use a variety of techniques for trunks and foliage.

For these simple scenes, you'll paint a swath of colors in the rough shape of a forest's edge across the middle of a dry piece of paper. Use large brushes to put down light colors first. While these are still wet, you'll add darker colors for contrast and to define the skyline. When this has all dried to the damp stage, you have the option of manipulating and adding to the colors in many ways (scraping, dropping color or water, blotting, adding salt, etc.). Don't get carried away; using a few techniques is usually better than using every trick in your bag.

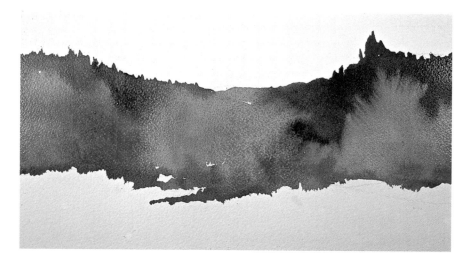

1. Lay Down Autumn Colors

Use vertical strokes to lay down an irregular swath of autumn colors (oranges, pinks, greens, yellows, etc.). Let one color flow into the next.

While still wet, add dark evergreens to establish the top edges of your forest and to create internal contrast.

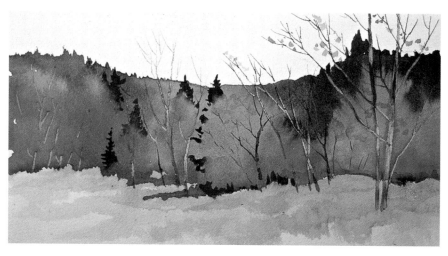

2. Add Detail

To add additional evergreens just paint a portion of their tops and then fade this downward into the forest. Add dark trunks and limbs with a palette knife or brush to complete your trees. Finish the foreground as you wish.

1. Paint the Shades of Winter

Use pale, cool grays to define your forest shape. While this is wet, stroke in a few hints of warm color (siennas, ochres, pinks). Darken the skyline with evergreen treetops and the ground line with darker gray.

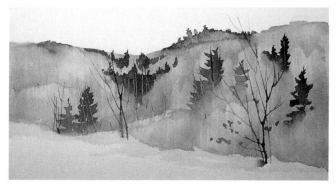

2. Suggest Without Overstating

Suggest some of the subtle edges of the tree clumps and ridges with a medium gray, then fade this out and upward into the background. Let dry.

To simulate bare tree trunks, drybrush vertical lines over your forest with a hog-hair bristle brush loaded with pale gray. Let dry.

Add dark evergreens by painting a portion of their tops and fading them downward into the forest. Extend a few dark tree trunks and limbs above and below the forest shape. Drybrush a few twigs using a pale, warm gray.

1. Start With Summer Greens

The challenge here is to create a variety of greens. First, put down patches of light warm and cool greens. While wet, dab in dark greens for contrast and also to define the skyline and ground line. Leave a light area so you can paint darker trees in front later. (I used masking tape to save a beach line.) When damp, scrape in a few tree trunks.

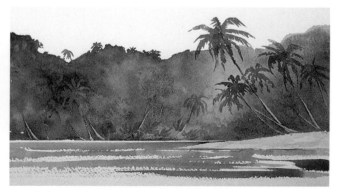

2. Finish With Positive and Negative Painting

Paint the dark positive trees in front of the light area. Negative paint the suggestion of treetops in the background. Add the beach, water and shadows. Mauve is good for balancing all those greens.

Lighting in the Forest

Where you put branches and trunks has a profound effect on the illusion of light direction. This exercise will help you understand the effect. More examples of it are in the tree demos to follow.

1. Prepare the Backgrounds

Pre-paint two backgrounds. To make your backgrounds, first paint a roughly circular gradation of greens that covers your entire paper. Start with light warm greens (Sap Green + yellow) in the center and work to light cool greens (Sap Green + blue) around the outside. Let dry. (You could wet the paper first, but it is unnecessary if you use large brushes and work quickly.)

2. Add the Leaves

When this is dry, sponge on irregular clumps of leaves in dark-to-medium greens. Even though you want about 50-percent coverage of the background, try to make the sizes of the clumps and spaces vary. Let dry.

3. Add Trunks and Branches

Use a no. 8 to no. 12 round and a dark blue-brown mixture. On one background, paint the trunks and branches only in the dark areas. Now your trees are front-lit. To complete the illusion, scrub off a few sun spots on the trunks when they are dry.

On the other background, paint trunks and branches only in the light areas. Suddenly your trees are backlit.

1

2

3

Backlit Forest Meadow

The backlit effect, which you just saw in the last exercise, is achieved when dark trunks and limbs are visible in the light patches of your background. We will be doing the same thing here except we will be changing the value and temperature of the dark leaves and trying a different way of painting a meadow.

TIP

To create a very dark color with a sponge, first make the shape you want and then—while just touching the mark with the tip of the sponge—squeeze out color. This is also a good way to add a different color to a shape.

1. Paint a Graded Wash for the Background

Roughly define with pencil where the forest ends and the meadow starts. Wet your paper. Paint a circular graded wash that starts with a pale pink at the light source and gradates to a cool blue-green around the edges. Use Raw Sienna and Permanent Rose at the center, and gradate through yellow-green to Sap Green, Phthalo Green, then Cobalt Blue at the edges. Fade your colors into the meadow area. Let dry.

2. Sponge on the Leaves

Sponge on irregular clumps of leaves that gradate from very dark and warm over the light source, to medium value and cool around the outside. Vary the size and distribution of these clumps. Let this dry, but don't wash your sponge.

3. Build Foliage and Try a New Meadow Treatment

Sponge more of the dark foliage colors along the top edge of the meadow, covering some of the previously painted foliage. Immediately tilt your paper and spray water loosely along the top of the meadow. Keep spraying until the paint runs down in a lacy pattern over your foreground. Lay your painting flat to dry.

4. Add Final Details

Paint tree trunks and branches in the light areas. Use something, such as a fence, to define the edge of the meadow. Notice that, like the tree trunks, it is not completely visible.

SUMMER LIGHT
11" × 14" (28cm × 36cm)

Edge of the Forest

We could now do a frontlit exercise where all the tree trunks are light against a dark background, but instead we will do one that mixes things up a bit: the base of the tree will be light against dark, but dark against light farther up. You'll see why later.

1. Paint the Tree Area

Paint the tree area in the light mottled colors of the spring season. I chose Raw Sienna, Sap Green and Phthalo Green. The foreground meadow is painted lighter than the forest. Let dry.

2. Add Irregular Edges and Texture

Use a sponge and/or a large brush and a darker, cooler version of the background colors to define some of the irregular edges of the major trees. Vary the width of your marks and fade them out into the background colors.

3. Darken the Grasses and Foliage

Use the same process with the same colors to define some even darker spaces in the foliage. Use a brush to carefully paint around the base of major tree trunks. Darken the meadow grass in the foreground with some Sap Green and Burnt Sienna to suggest that the viewer is in the shade. Remove a few light blades of grass with a damp brush. Let dry.

4. Add Final Details

Sponge midvalue marks onto the face of the tree. Fade out some of the edges of these marks. Use very dark color to redefine the bottom of the tree trunks while saving a couple of midvalue trunks inside the forest.

To achieve the front-lit effect, extend the tree trunks and branches into the trees by painting them dark in the lighter valued spaces. When dry, add cast shadows on the lower tree trunks and wipe back a few sunspots on the dark portions. Add sky above the trees and detail to the foreground grasses.

EDGE OF THE GREENWOOD
11" × 14" (28cm × 36cm)

VARIABLE CONTRASTS
This picture is also frontlit, but in reverse of the above painting. Here, the dark trunks and meadow are silhouetted against a light background while light limbs above are set against darkness. Each picture projects its own feeling because of different contrasts.

AUTUMN ENTRANCE
11" × 14" (28cm × 36cm)

Country Roads

The objective here is to capture the feel of a sun-dappled country road.

1. Set the Stage

Start by painting the road surface a medium-to-dark warm gray made from nonstaining colors— Cobalt Blue + Burnt Sienna or Cerulean Blue + Cadmium Orange. The darker you make the road, the brighter the sunspots will be. Add a pale yellow-green for the roadsides and sky.

2. Create the Dappled Sunspots

Create sunspots by using a spray bottle to flood the area, then lifting paint with a small scrub brush. These spots are really ovals of varying sizes and brightness. They should fan out in a pattern that adds a sense of perspective to your road.

When this dries, add more color and texture to the foliage on the sides of the road.

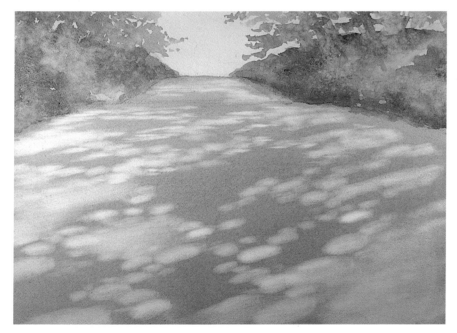

COLOR NOTE

To get the desired colors, make sure you're using a real Cerulean Blue (PB35 or PB36), not a mix of Phthalo Blue (PB15) and white. Read the label.

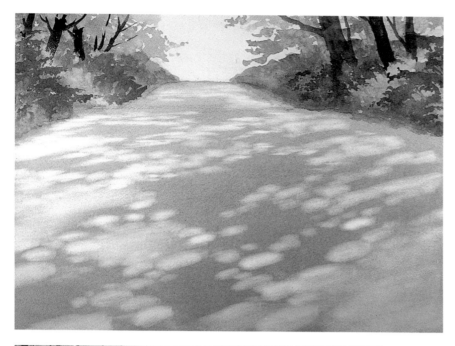

3. Complete Roadside Detail

Create more foliage detail with negative and positive painting. Use a pale blue-green for the distant trees to add a sense of depth. Add dark tree trunks and branches.

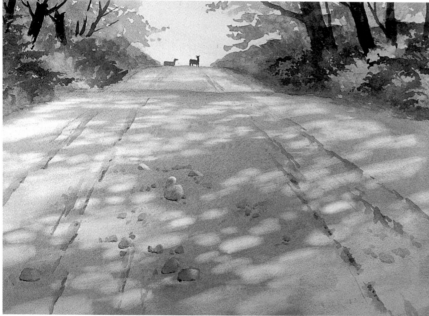

SIGHTINGS
11" × 15" (28cm × 38cm)

4. Paint Rocks and Ruts

Create ruts by painting broken lines with the original road color. Fade these out at random. Darken the rise in the road so that it is different from the road beyond.

Create some stones by painting them darker than the ground, especially on their shadow side. Create others using an acetate stencil and a scrub brush. Start by cutting small curved bits from the edge of a piece of acetate. Use your scrub brush and water and one of the notches in the acetate to remove only a small amount of paint for the sunlit side of the rock. When this dries, paint the remainder of the rock dark.

I've added the deer as a center of interest.

Snowstorm in the Forest

This is very much like painting fog. The many faces of winter offer grand opportunities to play with color temperature and purity. The snow is a mirror for the subtle atmospheres that surround it, from the pure warm and cool colors of a bright sunny day to the dulled subtlety of a snowstorm.

THE PLAN
This is a rough layout for the picture. It helps determine the areas to protect with masking fluid.

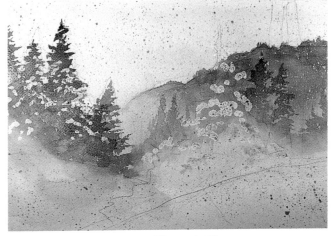

1. Apply Masking

Use masking fluid and a brush to save some snow on the limbs of the nearest trees. For the falling snow, spatter masking fluid over the entire surface with a toothbrush (see page 77). To avoid accidental drips, try to spatter the fluid onto the paper from outside the picture area. Don't be stingy with your snowflakes. When dry, paint a thin gray (Cobalt Blue + Burnt Sienna) wash over the entire paper.

2. Paint Background Hills and Trees

Paint the tops of distant hills in a light, cool, mottled gray (Cobalt Blue + Burnt Sienna). Fade this downward and let dry. Use a brush—or better still, a sponge—to paint the middle-ground trees with a midvalue gray. Treat these as a silhouette and fade them downward.

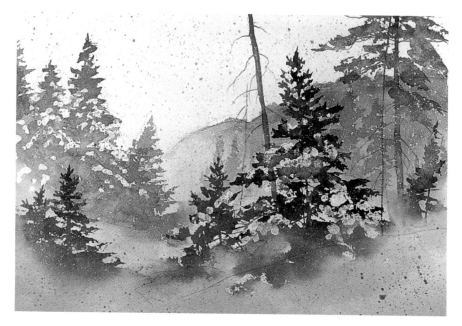

3. Paint the Foreground Trees

Using a sponge or brush, paint the foreground trees with a dark, warm gray that has just a hint of green in it. Try to make the branches match the clumps of snow that you masked out. Fade the bottom of these trees to suggest snowdrifts. Let dry.

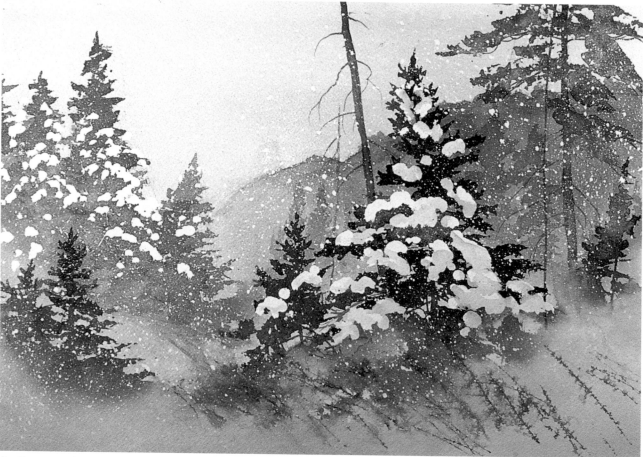

4. Remove the Masking and Add Shading

Spray the foreground with water and paint warm weeds and shrubs with the edge of a palette knife loaded with reddish brown. When everything is dry, remove all masking fluid and shade the undersides of the snow mounds with a pale, cool gray.

ON SILENT WINGS
11" × 15" (28cm × 38cm)

From Dusk to Dawn

It is said that we are children of the light and as such are attracted to it in real life and in visual presentations. But deep within us is also a personal response to the world of darkness. It is that buried sense of what night means to us, with all its assorted mysteries and intrigue, that we are after here.

Paintings set at this time of day have a quality that appeals to an entirely different and deeper level of knowing within the viewer as well. For many, night is not a time of gloom and dread but a time of excitement, fascination and even comfort. It has the ability to stir things in the twilight of our memories that somehow connects us to the distant and long ago.

There are some special factors to consider when depicting this time of day. You must decide on the light sources in your picture; their strength and direction and what they illuminate. You also have to decide how much illumination is necessary to reveal the subject, or how much of the subject can be obscured by darkness and still convey what it is. Detail is not a factor at night. Creating illusion by suggestion is everything.

Some light sources need to be saved by masking while others can be created during the painting process or by scrubbing out later. Glazing can also be used at the end to subdue certain areas while causing the eye to see others.

The following two exercises are an introduction to some of the techniques used in night painting.

COLOR NOTE

Use a triad of Indigo, Permanent Rose and Raw Sienna or Burnt Sienna. When mixed together, these colors produce others that are subdued.

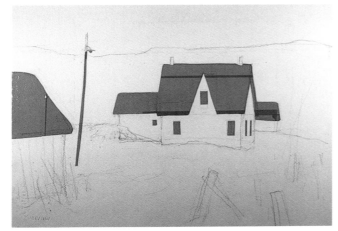

1. Mask the Light Sources and Surfaces

In this exercise, the homestead windows, yard light and the sky are the sources of illumination. Mask these as well as the roofs with masking fluid or packing tape.

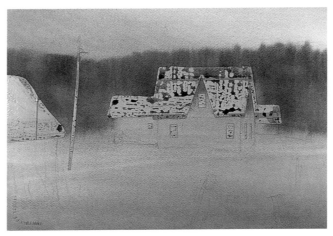

2. Lay In the First Washes

Mix a large puddle of warm gray using your triad colors. ("Warm" meaning the Permanent Rose or Raw Sienna will dominate.) Wet your entire paper and apply the gray over the surface. Use more color to darken the right side of the horizon. Lighten the left side by lifting pigment with a damp brush. Immediately mix a more concentrated form of the gray and paint the background trees. Blend this forward into the fields. Let dry.

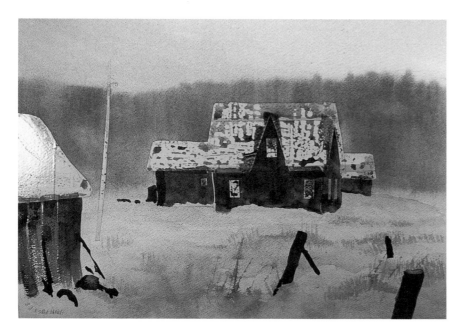

3. Add Grass and the Darkest Values

Use drybrushing with more of the original light-wash color for random clumps of dead grass. Fade out as necessary. Let dry.

Paint the sides of the buildings and yard objects using a dark mix of the original triad colors. Let dry.

SUPPER'S READY
11" × 15"
(28cm × 38cm)

4. Develop the Light Details

Remove the masking. Gradate the window openings from Burnt Sienna to Raw Sienna in the center. Gradate the lamp pole from dark at the base to light at the top. Paint it dark above the light. Cut a wide "V" out of a piece of paper or acetate. Invert this and lay it over the paper. Use a damp sponge to lift pigment to suggest an area of light rays from the yard lamp. With a small scrub brush, lighten the center of some of the windows and the illuminated areas of snow. Paint the roofs a cooler light gray and then model the ground a bit with the same gray. When everything is dry, paint the tree with a palette knife.

Under the Stars

This night exercise involves masking with masking fluid and painting the transition of colors from dark and cool to light and warm. The light source is a campfire that is unseen but emitting smoke and light that reflects off the tree trunks and leaves.

1. Mask Light Areas and Lay In Initial Colors

Use masking fluid to save the limbs and trunks of the major trees, background rocks and the two figures and tent to the left. When the masking fluid is dry, paint a concentric graded wash that ranges from pale Raw Sienna at the campfire to Sap Green then Phthalo Green at the top of the tree line. Paint over the foreground rock as well. When this has dried, paint the sky a dark blue-gray (Indigo + Phthalo Blue) down to the tree line. Let dry.

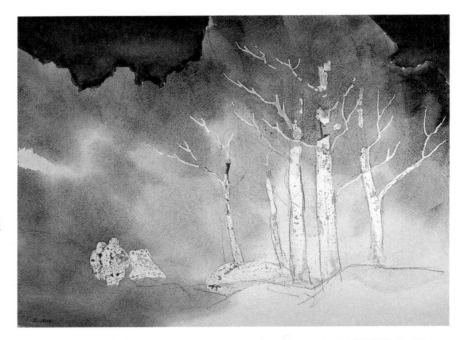

2. Paint the Foliage

Use a sponge loaded with a extra-dark blue-gray (Indigo + Sepia) to define the tops of the distant trees against the sky. Use the bottom of these marks to indicate the lighter tops of closer trees. Soften the back edges of your marks. As you move closer to the light source, add Phthalo Green, then Sap Green, then Raw Sienna and water to your mix so your colors get warmer and lighter as you go. Paint the area around the figures dark. Paint the large foreground rock a warm gray (Cobalt Blue + Burnt Sienna).

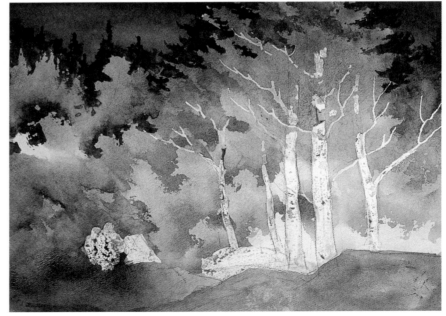

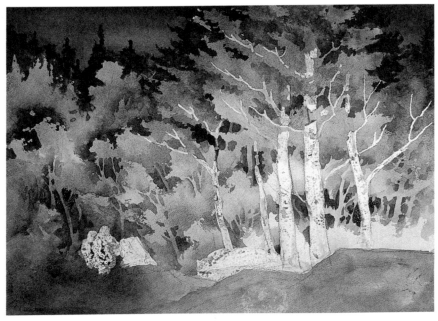

3. Create the Trees with Negative Painting

Take your time to create background trunks, limbs and holes in the foliage using negative painting with your sponge and small brushes. Fade out your dark marks so the lighter edges and limbs will stand out.

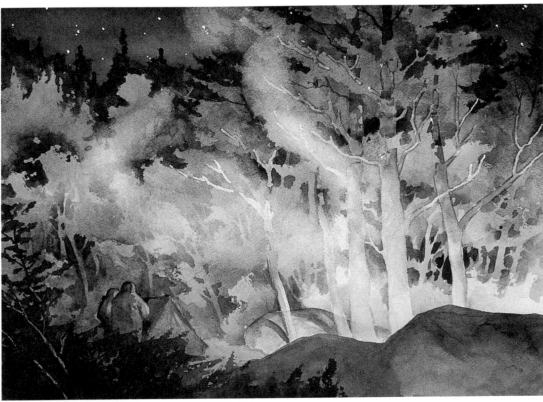

UNDER THE STARS
11" × 14"
(28cm × 36cm)

4. Add Final Details

When dry, remove all masking. Gradate the tree trunks and branches from dark brown at the top to Burnt Sienna, Raw Sienna and then white at the bottom. Paint the figures and tent Burnt Sienna. Let dry.

Cast shadows on the flat middle-ground rocks. Add dark shadows to the figures, tent and foreground rock until they almost blend into the darkness. Let dry.

With a damp sponge or toothbrush, gently remove some wafts of smoke, starting in the campfire area. Sponge on a dark blue-gray (Indigo + Phthalo Blue) for the foreground foliage on the left. Add stars by picking the paper with a razor knife.

Winter Hills

The plan is to have the warm, late-afternoon sun highlighting the hill-tops in this winter scene. This is another opportunity to play warm colors against cool.

1. Prepare the Background

If you want a cabin in your work, mask its roof with packing tape. Paint the entire land area (not the lake) a pale, dull Cobalt Blue. While this is still wet, add pale reddish brown (Burnt Sienna + Permanent Rose) along the hilltops. Work this in with your brush to push the blue aside. Lift paint to make it lighter. Let dry.

Now comes the part that takes nerve. To capture the illusion of bare trees on the hills, mix a pale, warm gray (Burnt Sienna + Cobalt Blue). Drybrush it from the top of the hill to the bottom using long vertical strokes. A large bristle brush with fanned-out bristles works well for this. Don't paint the foreground ridge. Let dry.

2. Stencil the Ridges

Now for the fun part. To create the illusion of ridges on the hill, use the same brush loaded with warm gray and a few pieces of torn paper as stencils. Place a piece of torn paper on the painting, then, starting on the stencil, drag your brush upward for a short distance. To change the bend of a ridge, simply shift the stencil, but make sure your strokes remain vertical. For the top edge of your hill, make strokes downward. Try to create a natural flow in the location, direction and spacing of your ridges. They will get closer together as you work over the top of a hill or into the distance.

COLOR NOTE

The major colors here are Burnt Sienna and Cobalt Blue. The minor colors are Permanent Rose and Sap Green. These represent two complementary pairs.

EVERGREEN TECHNIQUE
USED IN STEP 3
Load your brush and hold it low and flat to the paper. Lower your brush and just touch the paper with one corner of the bristles. Press down lightly and lift off.

The triangular mark that you have stamped on the paper with your brush creates the impression of a distant evergreen. Vary the size and width by changing pressure and angle. By stamping repeatedly, you can create a clump or row of trees.

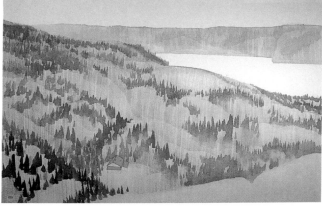

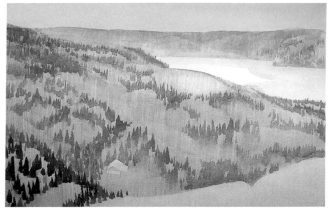

3. Add Evergreens

These evergreens are not actually green. They are a range of warm-to-cool dark grays made by mixing Cobalt Blue + Burnt Sienna. (You could also mix Sap Green + Permanent Rose to get a dark, dull green). Following the brush technique on the previous page, make your trees one at a time or in clusters using a 1-inch (25mm) flat hog-bristle brush. Practice this on a piece of scrap paper first.

4. Paint the Sky and Shadows

Add a few pale evergreens to the far shore. Paint the sky with a pale Burnt Sienna + Permanent Rose.

Remove the masking from the cabin roofs. With a large flat brush, quickly glaze Cobalt Blue over the shadow area in the valley. Use the same color for cast shadows on the lake. Let dry.

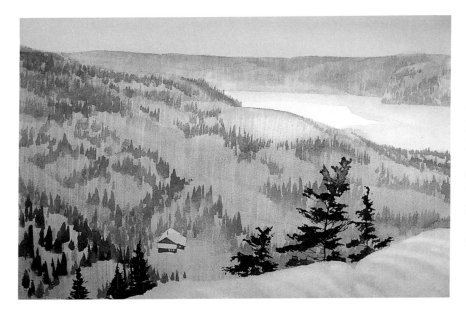

5. Add Finishing Touches

Use your scrub brush and lots of water to scrub back the sun on the foreground ridge. When this is dry, paint the sides of the cabins and a few nearby dark pines (Cobalt Blue + Burnt Sienna + Sap Green). The tops can be lightened by scrubbing the middle of the tree tip, blotting and then adding pale Sap Green.

SOLITUDE
15" × 22" (38cm × 56cm)

Autumn Glow

Do you remember the last time you came home from a drive in the autumn countryside? It was probably not the trees and hills in particular that you remember, but the emotional impact of their colors. Those who have learned to see with their heart know that it is not just single colors but combinations, profound and subtle, that touch chords deep within your being. It is that visually exciting interplay of hues that we are after here. In this exercise, the medium does the mixing in ways we never could.

COLOR NOTE

Prepare pools of the colors before you start. I would suggest pale mauve and yellow-green mixtures, as well as Cobalt Blue, Indian Yellow, Lemon Yellow and Permanent Rose.

1. Let the Medium Do the Work

Wet the entire hill and paint a mingled wash of pale blues and mauves over the whole area. *Immediately* start dabbing your warm colors into this cool wash using a large round brush, starting with yellows and oranges in the distance. Leave space between your marks so that some blue/mauve can show through. Create "blossoms" in the damp paint with drops of water. You should be getting some wonderful play of warm and cool colors and subtle grays emerging. Stop while it is still fresh. Let dry.

A thumbnail sketch indicates the flow of ridges on the side of the hill.

SOMETIMES LESS IS MORE
This is a field sketch I did after I had done two detailed sketches of the same subject. I like this one best of all because it is able to speak freely and differently every time I look at it. It can do this because I have not tried to confine it to one possibility of what it could be.

2. Add Just Enough Detail

How much detail you add to your impression of hills is up to you. You could define the tops of trees or distant ridges by painting dark behind them with a brush or sponge and fading upward. The "dark" could be any mixture of the colors used so far. Those same colors, when concentrated, can produce a dark, dull green that could be used for evergreens. Evergreens are good for contrast as well as leading the eye along ridges.

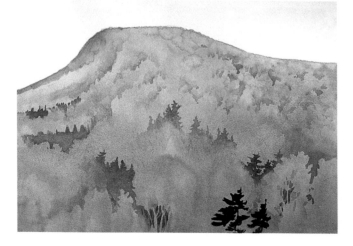

Mist in the Hills

These hills are created by painting their tops dark and fading downward. This will create the illusion of humidity hanging in the valleys. You will be starting with the farthest hills and working forward.

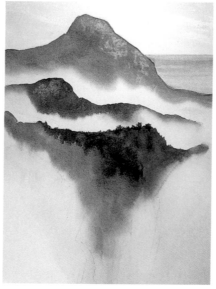

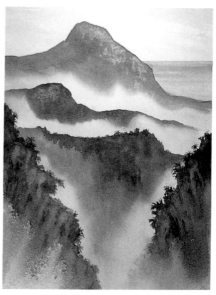

1. Paint the Farthest Hill

If you wish, paint the sky and water now. Since the land dominates, keep them simple. Let dry.

Paint the top of the background hills a dark blue-green (Cobalt Blue + a touch of Sap Green). Make the bottom edge irregular. Immediately wet the area below it with a damp bristle brush to fade out the color. Tilting your paper will help. Add more color along the top if needed.

For texture, try rolling a crumpled paper towel across the mountain while it is still damp. Let dry.

2. Change Color on the Next Ridges

Repeat the same process with the next couple of ridges, letting the paint dry between each. Use a bluish green (Cobalt Blue + Sap Green) for the first one and a greenish blue (Sap Green + Cobalt Blue) for the next. Start indicating vegetation by painting irregular edges on your ridges. Carry this down and fade out in the valley. Go back and add ridge detail now. Let dry.

COLOR NOTE

Except for some yellow-green in the foreground hills, all the land is painted with varying mixtures of Cobalt Blue and Sap Green.

3. Add the Foreground Ridges

Paint the right side of the split ridge first. This time, fade out by spraying. Place a good puddle of concentrated dark green (Sap Green + a touch of Cobalt Blue) along the edge of the ridge. Quickly tilt your paper and spray the edge of the paint. Direct the runoff away from the gorge. Add drops of yellow-green along the top and let these run down. Use a small brush to capture detail along the edge before it dries. When dry, repeat the process of painting and spraying on the left side of the gorge.

When the painting is thoroughly dry (overnight), glaze some of the mist with a pale Cobalt Blue using a large brush and very few strokes.

OUT OF THE MISTS
14" × 11" (36cm × 28cm)

Arid Hills

These hills provide a temperature and humidity contrast with the previous hills. To capture the warm, arid atmosphere, I warmed up my palette with Raw Sienna, Burnt Sienna, Permanent Rose and Cadmium Red Light, and I added Cerulean Blue (which is a dulled blue). I also used a little Phthalo Blue.

COLOR NOTE

To get the desired colors, make sure you're using a real Cerulean Blue (PB35 or PB36), not a mix of Phthalo Blue (PB15) and white. Read the label.

1. Establish the Atmosphere and Major Rocks

Paint a wash over the entire paper, starting with Raw Sienna and Burnt Sienna at the bottom and grading to pale Cerulean Blue at the top. While this is still wet to damp, paint the foreground rocks with concentrated Raw Sienna and Burnt Sienna with a small amount of Cadmium Red Light.

2. Model the Rocks by Scraping

When the foreground rocks dry to the damp stage, scrape back the light layers in the rock faces with a stiff palette knife.

3. Add the Distant Hills

Lightly sketch the distant hills, taking note of the areas you want to stay sunlit. Paint the shadow area as a continuous shape using a pale mix of Cerulean Blue + Cadmium Red Light. Fade out this color as you come forward. Let dry.

4. Define the Cliffs, Canyons and Ridges

Use a slightly darker version of the Cerulean Blue and Cadmium Red Light mixture to further define the cliffs, canyons and ridges in the distant shadow area. Keep the detail minimal in the sunlit areas. Paint the tops of the mesa and the vegetation on the slopes a pale, cool, dull green (Phthalo Blue + Burnt Sienna) in the distance.

5. Add Foreground Contrasts

Using a darker mix of Phthalo Blue + Burnt Sienna, paint an ascending ridge of trees to contrast with the rock faces. Paint the cracks and crevices in the rock faces using a concentrated warm gray (Cadmium Red Light + Cerulean Blue). Have a damp brush ready to fade out the edges. Drybrush the vegetation using a small hog-hair bristle brush. Glaze major shadow areas with pale Cerulean Blue.

ARID HILLS
11" × 14" (28cm × 36cm)

Snowy Mountains

If you plan to paint mountains beyond this exercise, I strongly suggest that you study the structure of the mountains of your choice. Try to understand what you are looking at. A mountain is more than a two-dimensional chunk of the earth; it's a three-dimensional sculpture in progress. Try to reconstruct how the "artists" of nature—avalanches, glaciers, wind and rain—have wrought a piece of the earth to awe-inspiring beauty.

Reconstruct how gravity has torn away rock and debris from the top of a range and deposited it on the slopes around its base. Look for the strata or layers that are exposed and the pitch at which they are set. These lines define the face of the mountain while indicating places where snow can't cling or vegetation can. Find the major ridges that have resisted the elements. They are the backbone of the work.

Record major ridges and valleys and strata in your thumbnail sketch.

1. Paint the Exposed Rock

Use a large round or 1-inch (25mm) hog-hair bristle brush to paint the exposed rock on your mountains using a cool gray. Here I used Cerulean Blue + Indigo, lightening the value to indicate distant peaks. Carefully work your way across and down the mountains, taking time to capture the essence of the lines and patterns found there. Paint far down the mountainside. Let dry.

2. Paint the Vegetation

Back up your mountainside and start indicating vegetation with a 1-inch (25mm) bristle brush. Follow the ridges and valleys using a mix that starts as mainly Cerulean Blue with a touch of Indigo and gradates to mainly Sap Green with Indigo near the base. For contrast, leave an area for light trees in the foreground. Paint these yellowish green (Sap Green + Raw Sienna) when the background is dry. Also leave an area for foreground land.

COLOR NOTE

The major colors here are Cerulean Blue, Indigo and Sap Green. The minor colors are Burnt Sienna, Raw Sienna and Phthalo Blue.

3. Add Mountain Shadows and the Forest

Use a large, synthetic flat brush to add shadows to your mountain with a pale blue-gray (Cerulean Blue + Indigo). Paint the dark evergreens with a concentrated Phthalo Blue + Burnt Sienna mixture. Soften the edges into the foreground bushes and scrape on light trunks with the tip of a palette knife.

> **TIP**
>
> Experiment with brush techniques (how you hold your brush and apply the stroke) on scrap paper before you start. You just might find a better way to make marks.

4. Paint the Sky and Final Details

Paint the sky by wetting it all over and then dropping Cerulean Blue at spots along the horizon. Tilt the painting upward so the blue runs off and white areas are left for the clouds.

Paint the foreground land a pale Raw Sienna. While this is damp, touch the area with a brush loaded with a darker green-brown texture and contrast with the light trees.

NEARING BANFF
11" × 14" (28cm × 36cm)

Index

The Best Art Instruction Comes From North Light Books!

You'll find 20 years of painting experience in Gordon MacKenzie's best-selling first book! MacKenzie focuses on the things that make a difference in your painting-the best paints to use, 3 no-fail approaches to composition and much more. Lots of illustrations and step-by-step demonstrations make key concepts and techniques fun to learn and easy to grasp.

ISBN-13 978-0-89134-946-4,
ISBN-10 0-89134-946-4,
HARDCOVER, 144 PAGES, #31443

A must-have for your tool kit, *The Watercolor Bible* gives you inspiring artwork, friendly, comprehensive instruction and indispensable advice for nearly every aspect of watercolor painting. It's small enough to take anywhere, and wirebound so you can flip it open and reference it while you paint!

ISBN-13 978-1-58180-648-9,
ISBN-10 1-5810-648-5,
HARDCOVER WITH CONCEALED WIRE-O, 304 PAGES, #33237

Award-winning artist Craig Nelson gives you a complete drawing course with easy, step-by-step instructions in both black-and-white and color. You'll explore all different mediums while learning crucial drawing principles and experimenting with mixed media, personal styles and more. With its hard cover and durable wire binding, *The Drawing Bible* is the perfect, portable reference tool.

ISBN-13 978-1-58180-620-5,
ISBN-10 1-58180-620-5,
HARDCOVER WITH CONCEALED WIRE-O, 304 PAGES, #33191

These books and other fine North Light titles are available at your local arts & crafts retailer, bookstore or online supplier.

title page
34
83 whitecaps
100 trees
112-113 conifers
129
134